KT-552-031

ACC. No. BK45035

CLASS No. 759.05/K

MID CHESHI LLEGE

ORDER 16748

the last

− 9 JUN 2000

BK45035

PEGASUS
*Library*

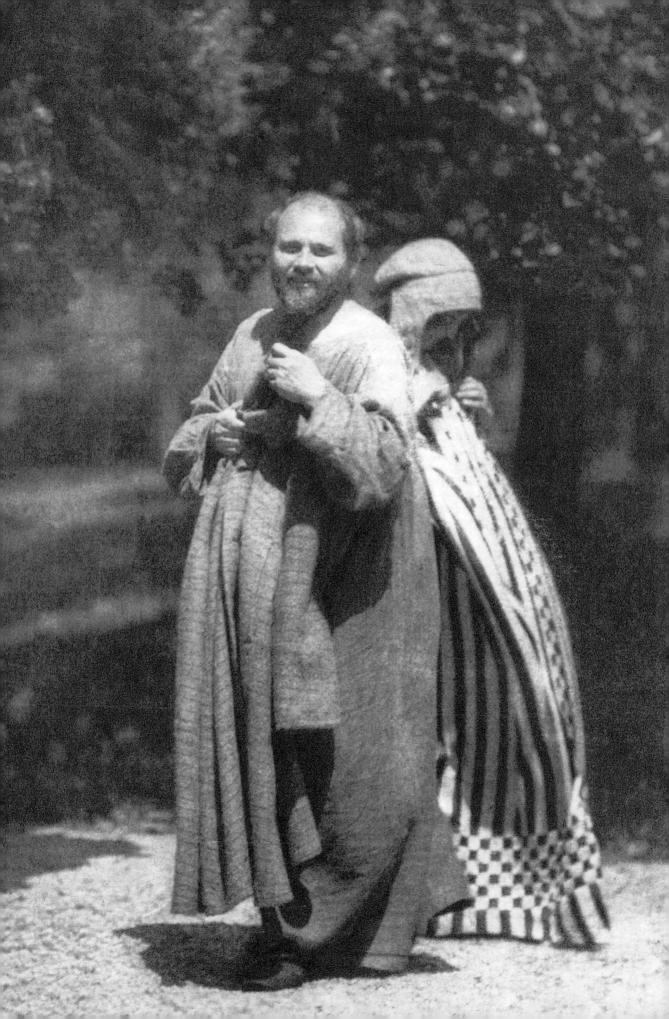

Front cover: *Danaë* (detail), *c.* 1907–08, (see p. 101)
Spine and back cover: *Portrait of Margarete Stonborough-Wittgenstein*, 1905, (see p. 43)
Frontispiece: Gustav Klimt and Emilie Flöge, photograph, *c.* 1905–06

The Library of Congress Cataloguing-in-Publication data is available;
British Library Cataloguing-in-Publication Data: a catalogue record for this
book is available from the British Library; Deutsche Bibliothek holds a record
of this publication in the Deutsche Nationalbibliografie; detailed biblio-
graphical data can be found under: http://dnb.ddb.de

© Prestel Verlag, Munich · Berlin · London · New York 2006
(First published in hardback)

Prestel Verlag
Königinstrasse 9, 80539 Munich
Tel. (089) 38 17 09-0; fax (089) 38 17 09-35

Prestel Publishing Ltd.
4 Bloomsbury Place, London WC1A 2QA
Tel. (020) 7323-5004; fax (020) 7636-8004

Prestel Publishing
900 Broadway, Suite 603, New York, NY 10003
Tel. (212) 995-2720; fax (212) 995-2733

www.prestel.com

Translated from the German by Michael Robinson
Copy-edited by Robert Williams

Typeset by Reinhard Amann, Aichstetten
Cover designed by Matthias Hauer
Typeface: Centaur
Originations by Fotolito Longo, Frangart, Italy
Printed an bound by Appl, Wemding

Printed in Germany on acid-free paper

ISBN 3-7913-3282-1
978-3-7913-3282-6

Susanna Partsch

# Gustav Klimt

## *Painter of Women*

Prestel

Munich · Berlin · London · New York

1  Emilie Floge, 1909

# Contents

# Klimt and Controversy
# in Turn-of-the-Century Vienna

Gustav Klimt, the *enfant terrible* of the Viennese art scene, was acknowledged to be *the* painter of beautiful women. He painted mythological goddesses and heroines, and produced portraits of *nouveau riche* Viennese ladies; at his death, he left thousands of erotic drawings. His *œuvre*, which was both wide-ranging and daring in the context of the time, was the subject of gossip and controversy – and not merely among artists – in turn-of-the-century Vienna. Admired and celebrated by young artists such as Egon Schiele and Oskar Kokoschka, watched with interest and rewarded by commissions from the liberal bourgeoisie, he was all the more sharply rejected by the academic world after his initial success.

The best example of this was the dissension, lasting several years, over his paintings for the Great Hall of Vienna University, which was conducted partly in academic disputes and partly in the local press. In March 1900, the writer and satirist Karl Kraus wrote in *Die Fackel* of the sketch for *Philosophy* (fig. 61),

2  Mizzi Zimmermann, ca. 1900

3  Hermine Klimt, before 1888

"Klimt's original sketch, I am told, showed a naked boy standing deep in thought; his long hair falling over his face, concealing the deep blush that may have shot into the immature lad's cheeks as he looks at two figures lying in a loving embrace in the picture above.... When the sketch was presented to the Commission, the current Rector of the University declared that it wasn't a painting of philosophy but a boy prematurely wondering where babies come from."

As a founder member of the Vienna Secession (1897), Klimt played a decisive part in the international breakthrough of Art Nouveau around 1900. By combining vibrant color, decorative figural ornament and often lascivious subject-matter he captured the pulsating feeling for life of an entire era. In particular, his portraits of women mark the turning-point from a predominantly academic style of painting, still influenced by historicism, to a symbolic-erotic approach to art, one that prefigured Expressionism.

The contradictions in Klimt's art and its public reception are also reflected in his lifestyle, which was outwardly conventional

4  *Study of a Head*, 1885

5  *Seated Nude*, 1913

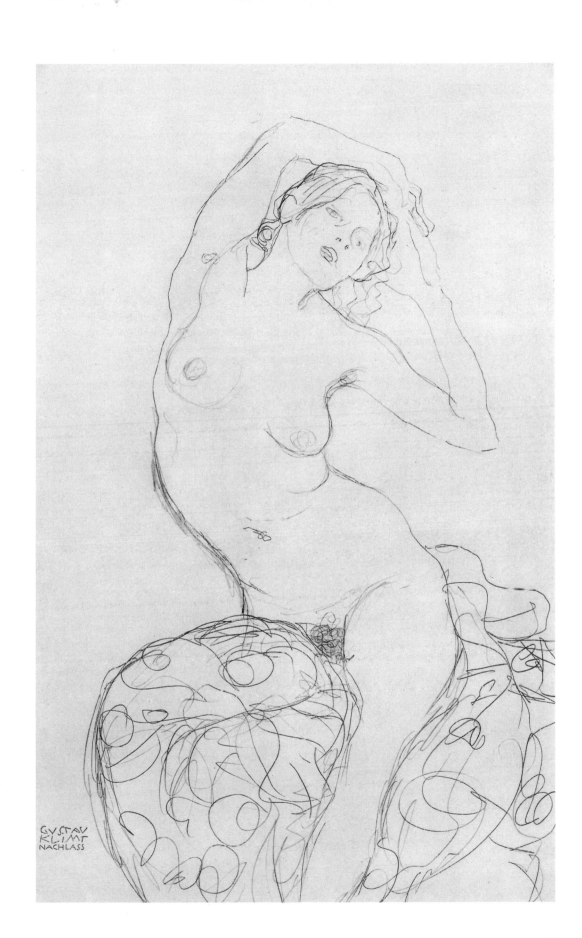

– he lived in an apartment with his mother and two of his sisters all his life, for example. Indeed his sister Hermine later claimed that he had been a very home-loving individual, spending almost every evening with the family and working in his studio during the day. In reality, however, he enjoyed a close relationship with his companion Emilie Flöge, and, with various of his models, fathered numerous children. Klimt, in fact, also liked to spend his evenings in Vienna's bars, playing bowls and drinking.

After his death, his plea not to be made the subject of bio-graphical inquiries was ignored: "I am convinced that I am not particularly interesting as a person...if anyone wants to find out about me – as an artist, the only capacity in which I am of any note – they should look carefully at my paintings and try to learn from them what I am and what I have tried to achieve."[1] Increasing interest in his work over the years has made his many-sided personality a subject of unremitting interest. Artist or upright citizen, bohemian or middle-class bore, sex-obsessed tyrant or sympathetic son and brother? Fantasy was given free rein....

# The Artist in Private and Public Life

Those in the public eye are expected to meet certain moral standards. When conflicts and problems become public knowledge, disillusion often ensues; however, this tends to lead not to more realistic insights, but to a search for a new vision of perfection. Artists today are permitted more elastic moral standards. If an artist succeeds in concealing his private life from public knowledge, it arouses suspicion; and after his or her

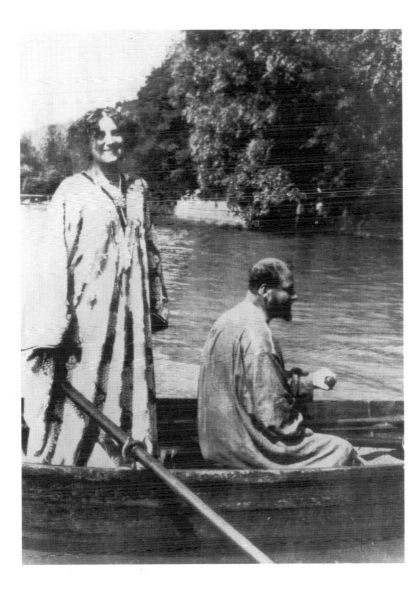

6   Gustav Klimt and Emilie Flöge in a rowboat on Lake Atter, ca. 1905

7/8  Following pages: Gustav Klimt and Emilie Flöge at Lake Atter, ca. 1910

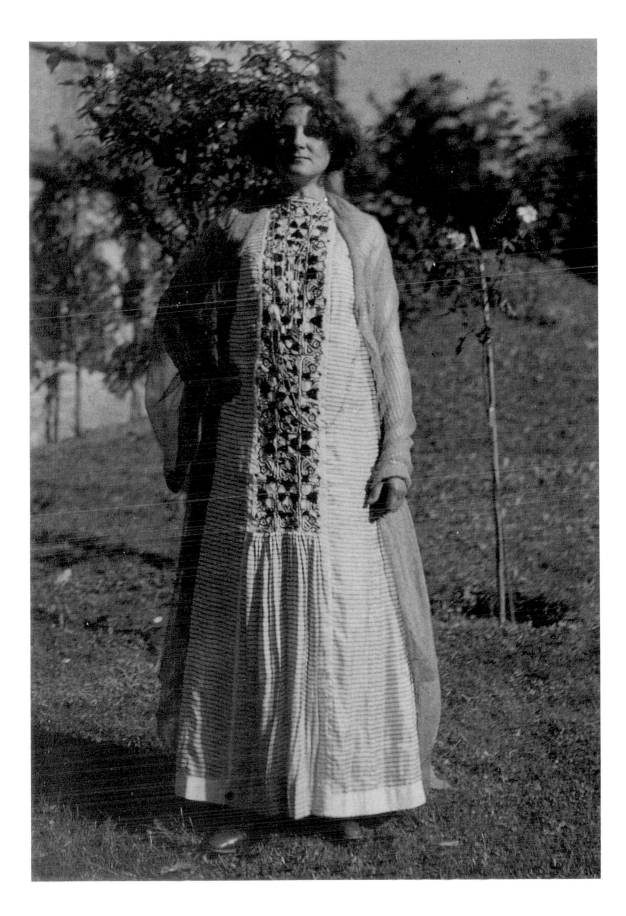

death, the doors are wide open to speculation. After Klimt's death there was tacit agreement that he enjoyed relationships with his models, while maintaining platonic relationships with society ladies and with his companion, Emilie Flöge. She was portrayed as the self-sacrificing partner whose only desire was to marry Klimt; because she understood and profoundly respected his artistic nature, she looked on passively as he turned his attention to other women. When he suffered a stroke on 11 January 1918, Klimt is alleged to have stammered, "Send for Emilie." Hans Tietze, in his obituary of 1919, drew the logical conclusion:

> For many years he was bound to a woman by the closest of friend-ships, but here, too, he was incapable of achieving a full affirmation. One is tempted to suspect that the erotic neurasthenia that trembles in many of his most sensitively felt drawings was based on the most painful experiences. Klimt never dared to take on the responsibil-ities that happiness brings with it, and the woman he loved for so many years was crowned merely with the privilege of attending him at his painful death.[2]

This view of their relationship has persisted, and as recently as 1969 a biographer wrote that Klimt, who spent vacations at Lake Atter in Upper Austria with the Flöge sisters, found in Emilie "the peace, poise, and friendship that he could not find anywhere else."[3] Emilie Flöge thus became a woman who "through her humanity, unshakable friendship, and infinite warmth knew how to give Klimt what he missed with the many other women to whom his hot-bloodedness drove him again and again."[4] Klimt the artist needed his freedom in order to be able to work. From the commonplace sentiment "a true artist lives only for his work," the conclusion was drawn that Klimt "needed to protect his personal freedom for the sake of his crea-tive work." This was why he did not marry "his Emilie." "Our respect for such a woman is so much the greater – a woman who devoted her life to serving a great man and who refused to inter-fere with his artistic career."[5] Not only his relationship with Emilie Flöge, his lifestyle in general has been distorted. Al-though contemporaries mentioned on various occasions that Klimt had an immense zest for life, that "as a bachelor, he lived

9   *Woman Crouching,* ca. 1907

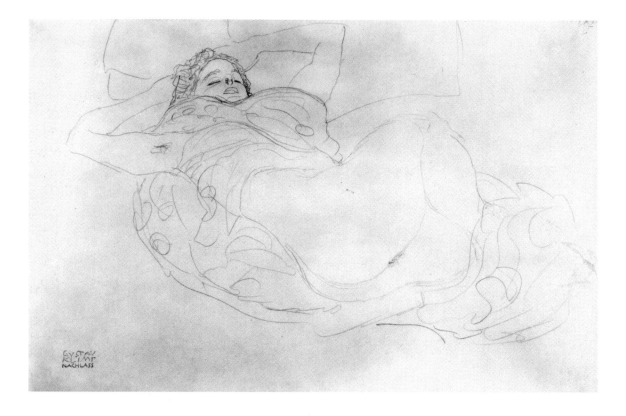

10   *Recumbent Semi-Nude, 1914-15*

the life of a convivial Viennese socialite, with wine, women, song, and games,"[6] and although this has in the meantime been confirmed from Klimt's own writings, a statement made by his sister Hermine as long after as 1940 continues to be peddled: "He was not a person for company, more of a loner, and as his sisters our concern was to relieve him of the burdens of everyday life. He came home to us every evening, ate his meal with very few words, and went to bed early...."[7]

Why did Klimt live at home with his mother and sisters? This suggested to some that Klimt's bond with his mother was very strong, possibly producing a fear of forming relationships with others of the female sex. The obvious conclusion therefore was that he was incapable of physical love for Emilie, his "object of desire."[8]

This sort of speculation was encouraged by the discovery in 1983 of some 400 postcards and a few letters written to Flöge by Klimt. If the biographers had been hoping for ardent declarations of love, they were to be bitterly disappointed. With the brief notes they bore, most of the postcards seemed at first glance to be insignificant. This was evidence that Klimt and Flöge can have enjoyed nothing more than a platonic relationship. Further confirmation of this appeared to be given by the daughter of their former neighbors at their summer resort at Lake Atter in 1985: "Emilie and Gustav – they were never a real couple, they didn't have a relationship! Never! It's the only explanation for Emilie's lifelong hypernervousness."[9] Elsewhere one reads: "Neither while Klimt was alive nor after his death did Emilie ever look for a relationship with anyone else, even though Klimt was obviously never prepared to condescend to do anything so horribly bourgeois as to make her an offer of marriage."[10]

No less than fourteen legal claims for maintenance payments were made after Klimt's death, four of which were accepted. The careers of three of his children are known of, at least in part. Several letters to his impoverished model Mizzi Zimmermann show that he made provisions for her and for their two sons. This and other relationships served to reinforce the belief that Klimt maintained an utterly platonic relationship with

Emilie Flöge. But this view of Klimt's "honorable" conduct was severely shaken in recent years by the discovery of two new sources of information. A letter from Klimt to the painter Carl Moll confirms Alma Mahler-Werfel's statement that Klimt had tried to seduce her during a journey in Italy that they made together. And an article published in 1986 points to a relationship between Klimt and Adele Bloch-Bauer, the wife of an influential banker and sugar manufacturer. In addition to her portraits (figs. 52, 57), she is also thought to have been the model for the paintings *Judith I* and *Judith II* (figs. 54, 56). Bloch-Bauer also claimed to be the woman featured in the famous painting *The Kiss* (fig. 60). With this information, the theory that Klimt made sexual advances toward his models, but upheld the manners of courtly love toward society ladies, falls apart. Christian Brandstätter thus recently also speculated about Klimt's relationships both with Sonja Knips (fig. 24) and Serena Lederer (fig. 30). With regard to the relationship with Emilie Flöge, by contrast, he asserts that "While he never invited her *into* his bed, when he was dying she was the only one he called to his bed*side*."[11]

How many women Klimt actually had love affairs with, or sought to, remains irrelevant to those who want simply to appreciate his art. But the extent to which women influenced Klimt's artistic work, and in what ways they stimulated him, are, however, matters of real interest. The correspondence recently discovered has not only provided information on Klimt's travels and at last allowed many of his works to be conclusively dated, it has also provided insights into his methods of working. Some interpretations of his works (for example, the *Stoclet Frieze*; fig. 37) have had to be abandoned, while others have been confirmed. The extent to which the various women concerned were involved in Klimt's work as an artist is the only possible justification for delving into his "affairs with women" once again. And Emilie Flöge has a special place here.

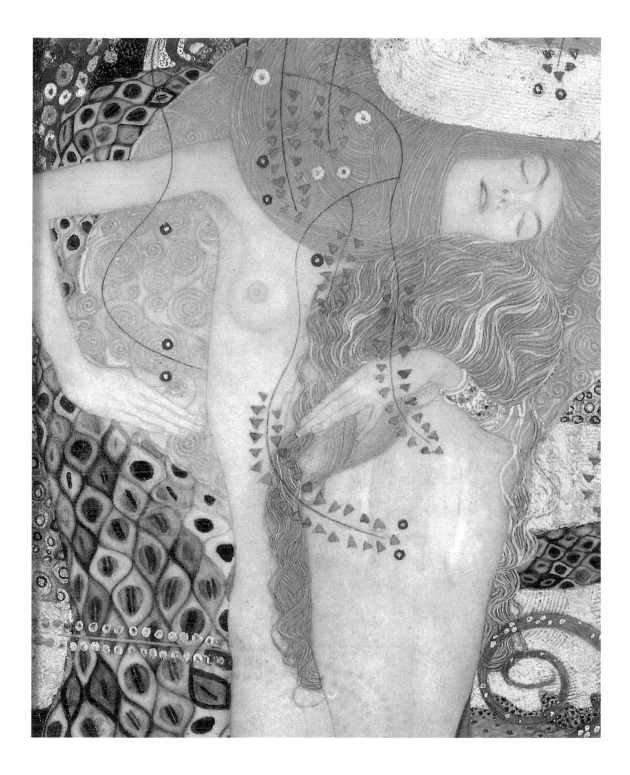

11 *Water Snakes I*, 1904 – 07. Detail

# Emilie and the Flöge Fashion-House

Emilie Flöge was born in Vienna on 30 August 1874, when Gustav Klimt was a 12-year-old schoolboy. Emilie was the fourth, and last, child of the meerschaum pipe manufacturer Hermann Flöge (1837-1897). Her grandfather, Hermann Martin Flöge, a master wood-turner, had emigrated to Vienna from what was then the kingdom of Hanover. Her father expanded the business, and with the healthy sales of his meerschaum pipes achieved relative affluence. Emilie's mother, Barbara, née Stagl (1840-1927), also came from a craftsman's family.

Emilie was christened as a Protestant, her father's religion. Her brother Hermann, born in 1863, is said to have taken over their father's business, but later worked as the director of the Vienna branch of a textiles company. Her oldest sister, Pauline (1866-1917), set up an educational establishment to train dressmakers in 1895, and therefore must herself have received a thorough education in that art. Whether their father also paid for Helene (1871-1936) and Emilie to learn dressmaking, or whether they were trained in their sister's establishment, is not known.

In 1892, the year Pauline opened her dressmaking school, Helene was already a widow, having married Klimt's younger brother, Ernst Klimt (1864-1892), in 1891. At that time the brothers were enjoying considerable success with the *Künstlercompagnie* (Company of Artists) they had founded back in 1881 together with a student friend, Franz Matsch (1861-1942). In 1888 Franz Josef, Emperor of Austria and King of Hungary, had awarded them a Gold Cross for the ceiling and lunette paintings on the staircases of the Vienna Burgtheater; in 1890 Klimt received the Emperor's prize for his painting of the *Auditorium of the Old Burgtheater* (fig. 12). As to when Ernst Klimt met Helene Flöge, the records are silent. By 1891 at the latest, however, Gustav Klimt, then 29, had met the 17-year-old Emilie. In the same year he painted his first portrait of her (fig. 19).

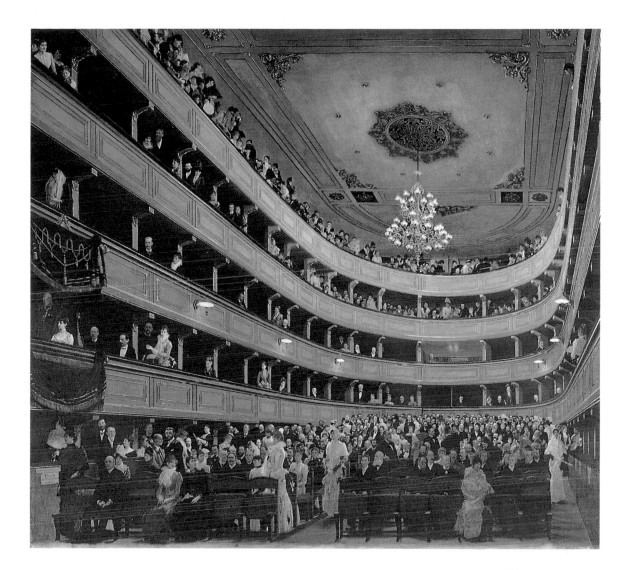

12 *Auditorium of the Old Burgtheater*, 1888

Ernst Klimt died on 9 December 1892. His daughter, Helene, was then not yet a year old, and Gustav became her guardian; in 1898 he painted a portrait (fig. 13) of his six-year-old niece.

In the winter of 1898-99 the Flöge sisters moved into an apartment at Mariahilfer Strasse 13, together with their mother. Soon after this they were apparently working as dressmakers (and no longer only in Pauline's educational establishment), since they were commissioned, on the basis of drafts they had submitted, to produce cambric dresses for a cookery exhibition. This substantial commission also seems to have been highly rewarding financially, for on 1 July 1904 they opened the "Flöge Fashion House" in the Casa Piccola at Mariahilfer Strasse 1b.

From the addresses written on two postcards sent to Emilie by Klimt, it appears that the sisters must already have moved into the large apartment in the Casa Piccola at some point between early June and late November 1903. The apartment provided enough space for them both to work and live comfortably. The fashion-house, or salon, was decorated by the Wiener Werkstätten (Vienna Workshops), founded in 1903; Josef Hoffmann (1870 - 1956) and Koloman Moser (1868 - 1918) were responsible for the interior design.

From the sign on the front door right down to the company labels (fig. 15) that were sewn into their dresses, everything was in the same style. The salon, which was entered through a lobby, was all in black and white (fig. 16). Into the white lacquered walls Moser set glued and colored paper designs, showing fashionable and elegant ladies. In addition to two tables and the high-backed chairs, the salon also had glass display-cases in which shows of the materials and costumes of the various peoples of Austria-Hungary alternated with craftwork from the Wiener Werkstätten (these were rediscovered in 1983 in the Flöge estate). The floor was covered in gray felt. This innovation (parquet was customary) had the advantage that customers could walk barefoot when trying on dresses, without any danger of getting their feet cold. As well as the salon there was an office, a mannequin room, and three changing-rooms, each fashionably equipped with adjustable mirrors (fig. 17).

Twenty seamstresses and two cutters were still employed in the three large workrooms in 1932 (before 1914 there are thought to have been 80 seamstresses). In addition to the Flöge sisters and Helene Donner, née Klimt (1892 - 1980), who took over her aunt Pauline's position in 1917, a bookkeeper and a model were also working there. In the private apartment, a cook, a housemaid, and a chauffeur were on hand to take care of the sisters' every need.

The decision to have an ensemble supplied by the Wiener Werkstätten may have been influenced by Gustav Klimt. But the business was also directed at a specific class of customer. The Flöge fashion-house was expensive; only the well-off could afford to patronize it. And among its customers are some of the

13  *Portrait of Helene Klimt, 1898*

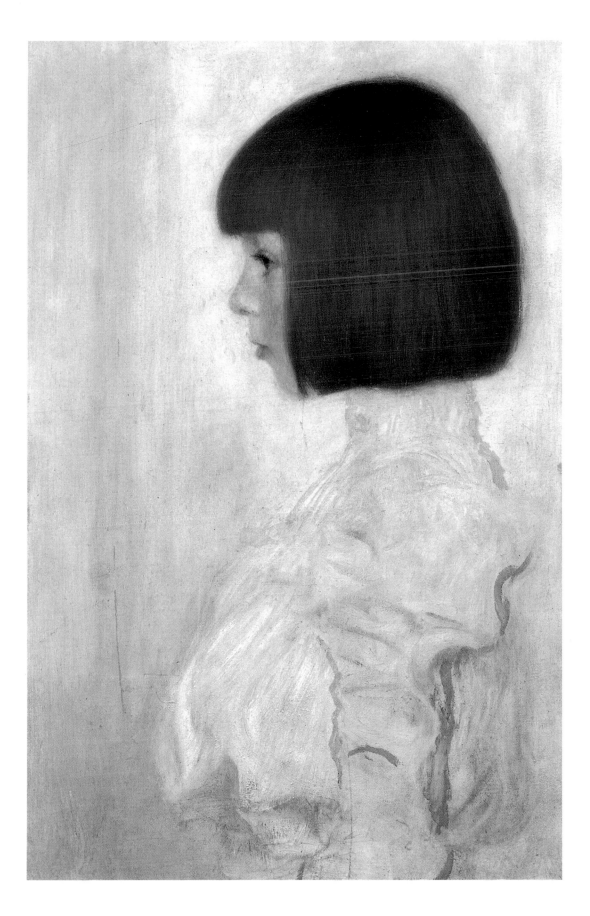

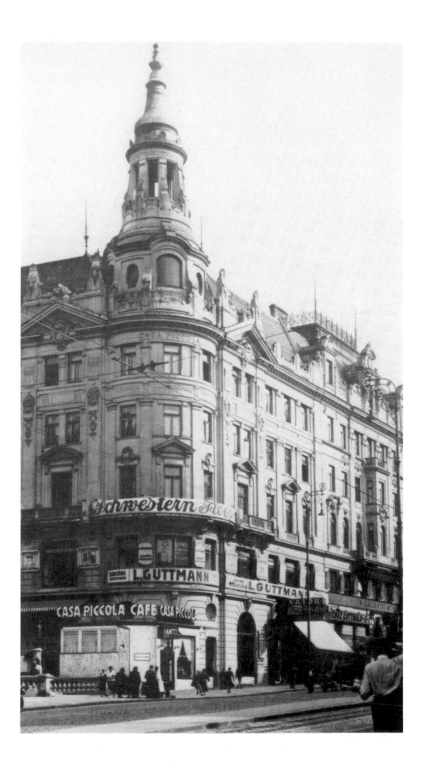

14  The Flöge sisters'
fashion-house located in the Casa
Piccola at Mariahilfer Strasse 1b
in Vienna's XIth District

women whose portraits Klimt painted. In 1909 Emilie Flöge and her sister Helene traveled to London and Paris for the first time to see the great fashion shows held there. Later, Emilie traveled alone each year to these two capitals, and purchased designs and materials from Coco Chanel and Rodier, among others. Reports are available from the period around 1932, but only two of the trips, in 1909 and 1913, can be dated exactly by the postcards sent by Klimt to Emilie.

The Flöge fashion-house never suffered from a lack of business. Even the recession that followed the First World War did not threaten it. Customers from the rich Viennese bourgeoisie continued to purchase items from the house. Because the sisters were never tied down to a single style, and alongside Parisian *haute couture* and London tastefulness supplied their own loose-fitting Reform Movement garments, they were able to satisfy a variety of tastes. It was only in 1938, after the German invasion, that Emilie Flöge and Helene Donner had to close down the business. Many of their customers were victims of financial expropriation (such as the Lederer family) or emigrated, while their American sales also ceased. The furnishings were sold off cheaply; Emilie Flöge only retained a few pieces of furniture from Klimt's studio and the folk-costume collection, with a few small accessories from the Wiener Werkstätten.

15 Company label for the "Flöge sisters"

16/17 Flöge sisters' fashion-house, reception room and changing rooms

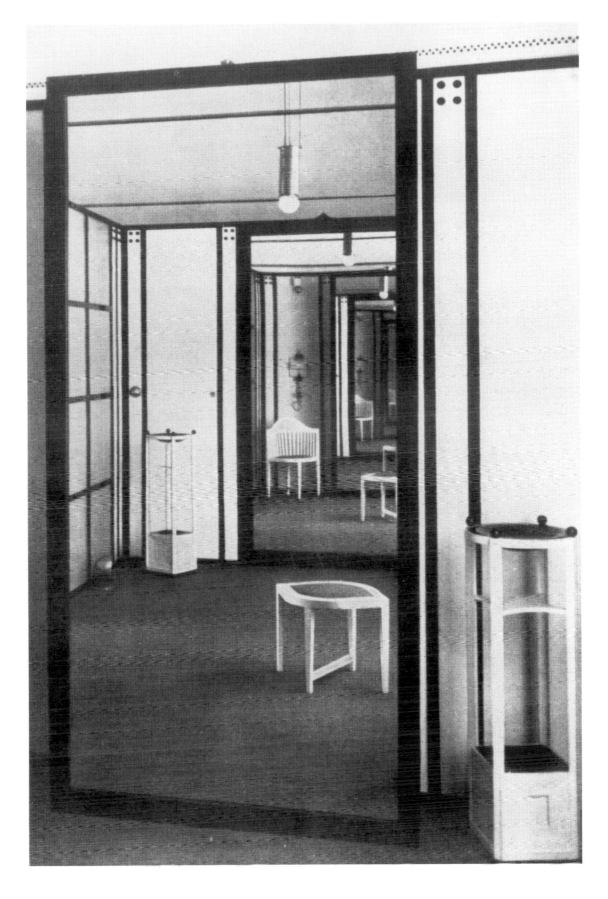

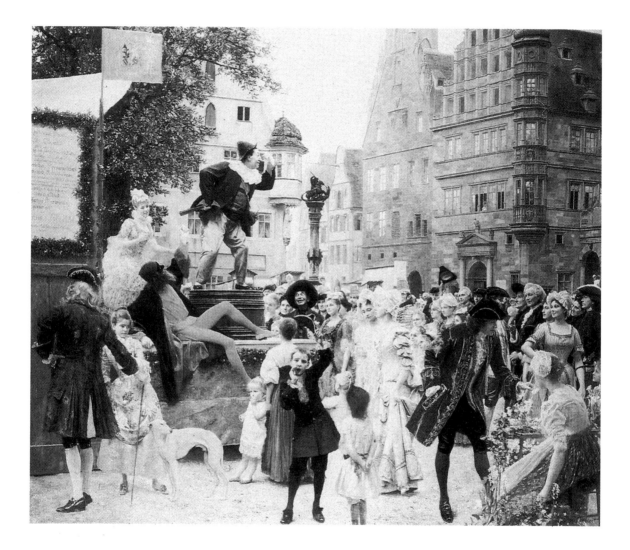

18  Ernst and Gustav Klimt, *The Clown on the Improvised Stage at Rothenburg,* 1893-94

# Emilie Flöge as Klimt Saw Her

Gustav Klimt painted Emilie Flöge four times. In 1891 he produced the painting that shows her in profile (fig. 20). It was one of the first portraits Klimt made. A year earlier he had portrayed the pianist and piano teacher Joseph Pembauer (fig. 19), a work that is a mixture of realism and Symbolist intensification. As with that portrait, Klimt also included the frame within his portrait of Emilie, decorating it with branches of flowering cherry, blades of grass, and flowers, recalling Japanese painting.

As Klimt often used members of his family as models during his first creative period, the portrait cannot be taken to indicate anything more than family links between Emilie, then age 17, and Klimt, a successful 29-year-old painter. Since the marriage of Ernst Klimt and Helene Flöge in 1891, the Flöges had, of course, been part of the family. Nor does the portrait of Emilie in the easel painting *The Clown on the Improvised Stage at Rothenburg* (fig. 18) or the associated study, both dating from 1893-94, allow any conclusions about a love affair to be drawn.

In the Burgtheater Ernst Klimt had executed the same subject as a ceiling fresco, and had then received a commission for a copy of it; the easel copy was left unfinished at his death. Gustav Klimt had to complete the painting, and he altered it, as can be seen from a contemporary photograph. He gave the observer standing at the center of the painting the characteristics of Emilie (fig. 21). The sisters Klimt and Flöge, as well as Emilie's mother, were also immortalized.

The study shows Emilie in the same historicizing costume as on the easel painting. Standing in front of a wall in a garden, she is framed on the right by a flowering oleander, and on the left by a thicket of trees, bushes, and flowers. The style of the depiction indicates that Klimt was by then turning away from his historicizing "Ringstrasse style," named after Vienna's fashionable thoroughfare, in the new buildings of which Klimt had executed

19  *Portrait of the Pianist and Piano Teacher Joseph Pembauer*, 1890

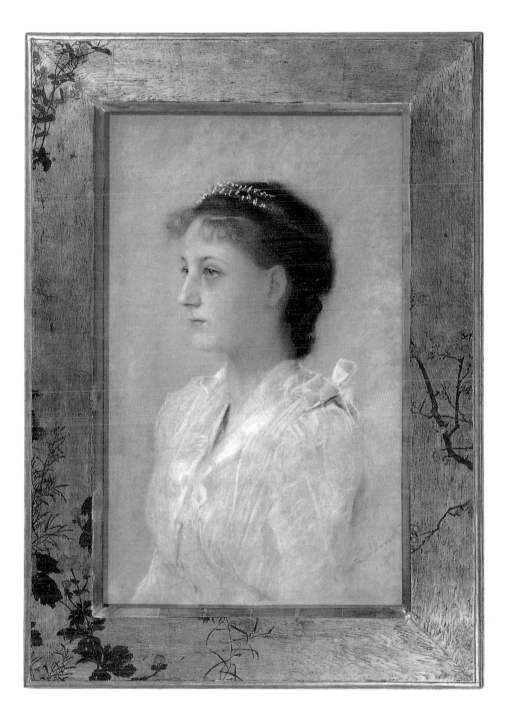

20   Emilie Flöge, aged 17, 1891

numerous works. The transitional style of the following years featured both Symbolist and Impressionist traits, until the period of his "Golden Style" commenced, which reached its climax in the *Beethoven Frieze* of 1902 (figs. 62, 63). Apart from the portraits of Sonja Knips (fig. 24), the study of 1891 is the only portrait by Klimt that includes a depiction of nature. It is quite possible that Emilie posed as a model in his studio in Josefstäderstrasse, which Klimt had moved into, along with his brother Ernst and Franz Matsch, in 1892. It was situated in an overgrown garden, surrounded by high walls.

The well-known portrait of Emilie of 1902 (fig. 25) radiates quite a different effect – although it does have similarities. Klimt presented Emilie in the same resolute attitude as in the study, only changing the position of the arms: her left hand is on her hip (now no longer visible in this work), while her right arm hangs down. With her body turned slightly to the side, her head is set in such a way that her gaze is fixed directly on the

21 *The Clown on the Improvised Stage at Rothenburg.* Detail of Emilie Flöge

22 *Portrait of Emilie Flöge*, ca. 1893

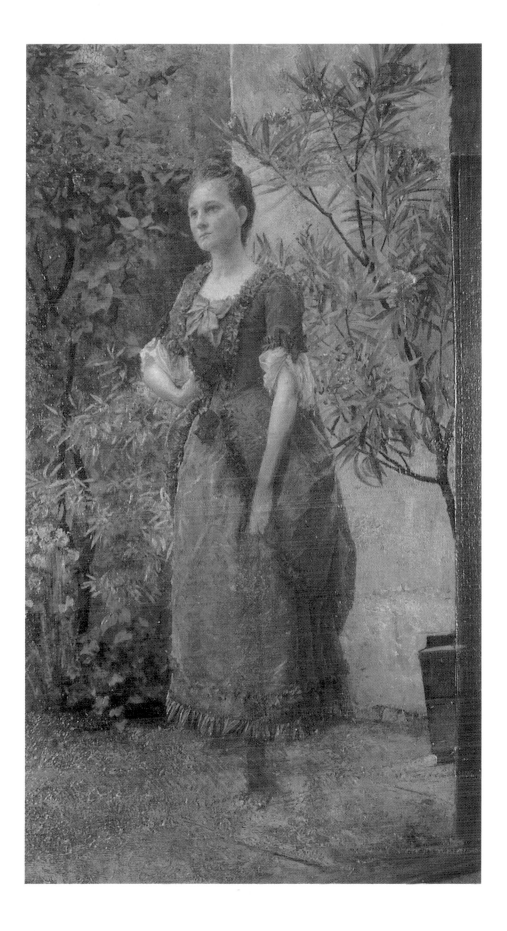

viewer of the painting. Her hair, no longer primly put up, frames her head with dark curls. The fan-like structure behind it has an effect like a halo.

The face, hands, and upper chest are all that can be seen of Emilie's body. The long, blue Reform Movement garment, studded with golden ornaments and spirals, falls to her feet, so that Emilie appears as a disembodied, two-dimensional figure (see fig. 27). But the alternating gray-green-pink forms that decorate her dress contrast with this and give the picture a depth not to be found in Klimt's other works of this period. The suggestion of a floor hints that the figure, despite its apparent etheriality, has two feet planted firmly on the ground. In comparison with the other portraits of women he produced during these years, Emilie also has a relatively stable quality here. In the portrait of Serena Lederer (fig. 30) of 1899 a floor is also visible, but the dress falls in such a way that the figure seems to be floating. And in the portrait of Margarete Stonborough-Wittgenstein (fig. 31), the background has dissolved into an ornamental surface with no depth at all.

The portrait of Emilie is an exception. It recalls — if only distantly — the study in which Klimt had not yet veiled the woman's body and granted her arms of flesh, blood, and

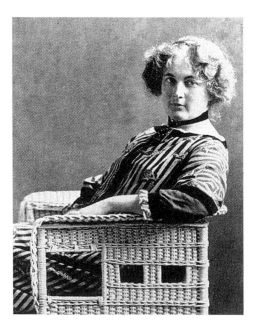

23  Sonja Knips, ca. 1911

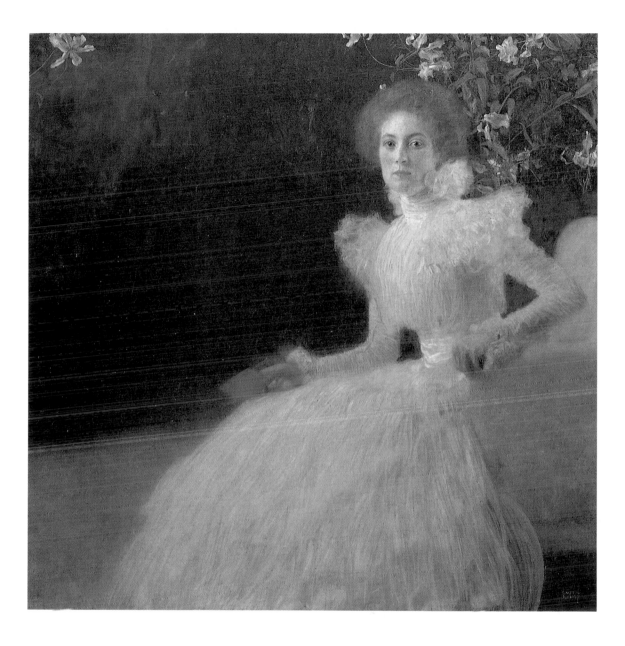

24 *Portrait of Sonja Knips*, 1898

muscle (!). Nor is the woman in the 1902 portrait – as Klimt sees her – a self-sacrificing martyr; she is, rather, a combination of enigmatic sphinx and resolute woman.

As mentioned, Emilie is wearing a Reform Movement dress in the portrait of 1902. This has always (and rightly) been linked to her professional work, and to the Reform Movement garments in which she was photographed by Klimt (figs. 32-34). However, it has not been noticed hitherto that although the painting is dated 1902, the Flöge sisters' fashion-house only opened in the summer of 1904. The portrait is, therefore, an indication that Emilie was concerned with extravagant fashion designs and the Reform Movement well before the fashion-house was set up.

The painting was sold in 1908 (Klimt wrote to Emilie at Lake Atter on 6 and 8 July to tell her of this), and later it was transferred to the Vienna's Historisches Museum der Stadt Wien. It is not known why it was sold, though it has been pointed out that Emilie herself did not like it. Nähr photographed it again, and either Klimt's or Flöge's mother (which of the two it was is not clear from the correspondence) "indignantly ordered a new portrait to be made as soon as possible" (6 July 1908).[12] Klimt did not carry out the commission. There are no later portraits of Emilie, and the suggestion that he immortalized her in *The Kiss* of 1907-08 (fig. 60) is more than dubious.

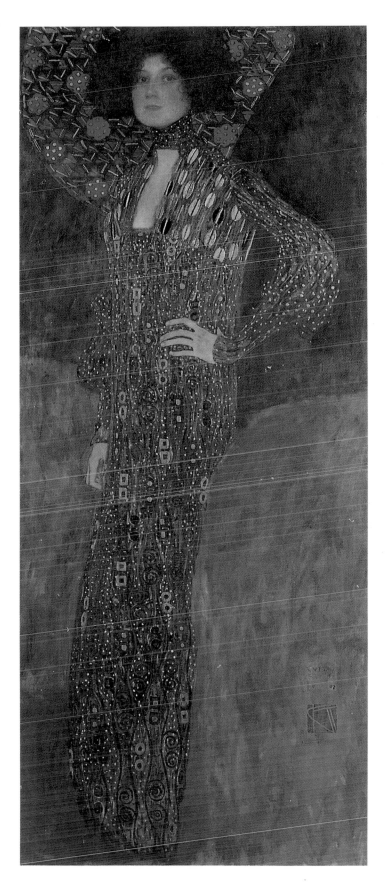

25   *Portrait of Emilie Flöge, 1902*

26  Study for *Water Snakes I*, 1903

27  *Water Snakes I (Girlfriends)*, 1904-07

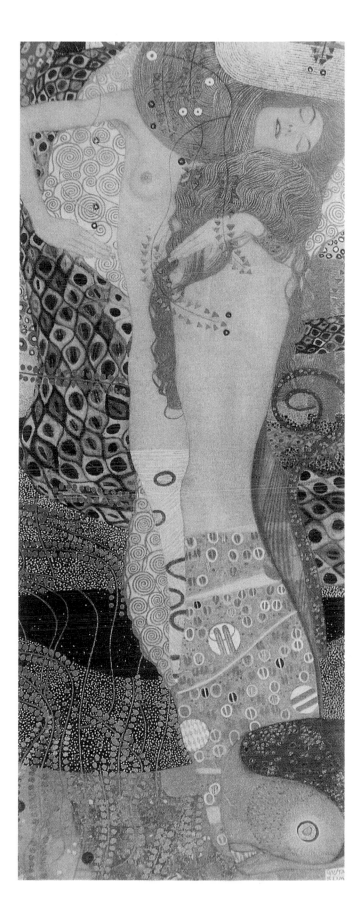

28   Study for *Water Snakes II*, 1907

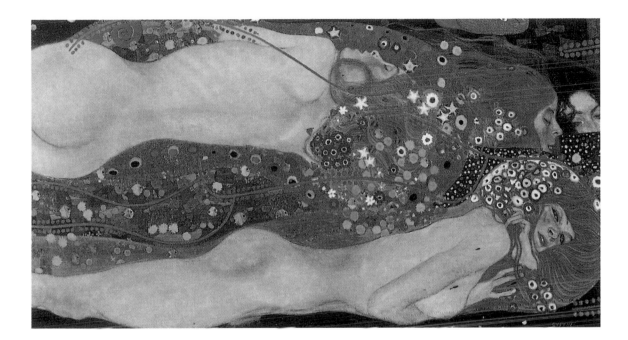

29   *Water Snakes II*, 1904-07

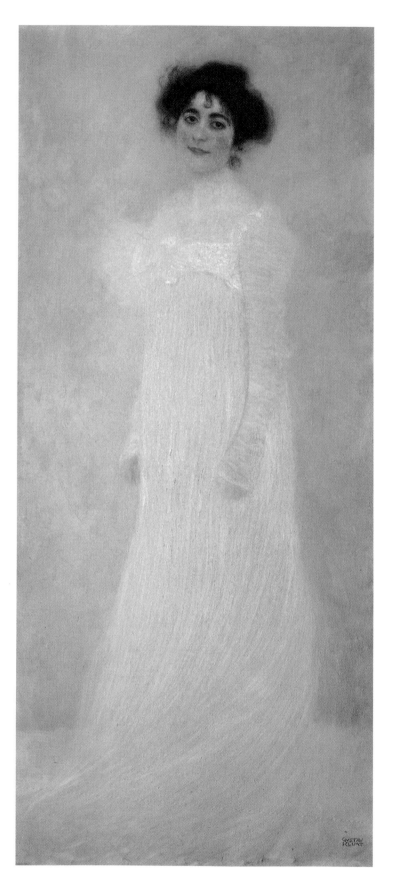

30  *Portrait of Serena Lederer, 1899*

31  *Portrait of Margarete Stonborough-Wittgenstein, 1905*

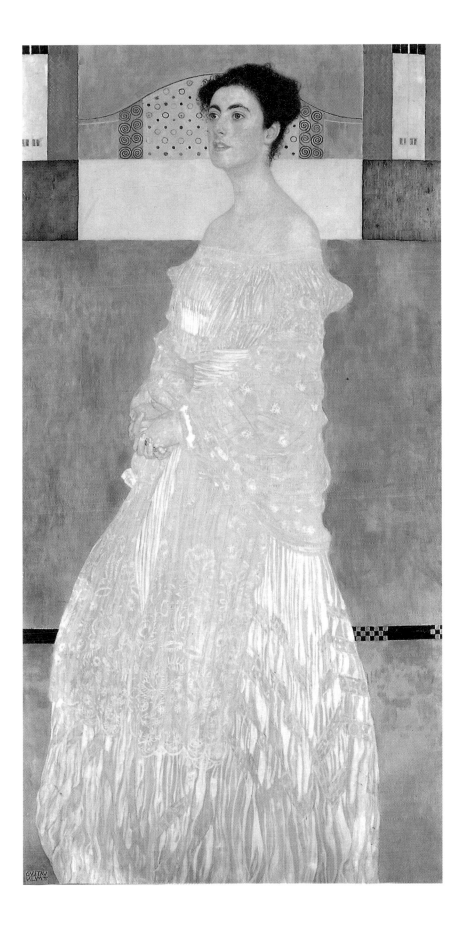

# Reform Movement Fashion:
## Expression of a Lifestyle

It was natural for the Art Nouveau artists, with their penchant for the total work of art, to have had an interest in fashion, and Klimt and Emilie had a unique opportunity to stimulate one another. The idea of dress reform, which was vigorously promoted in America, Britain, and Germany in the second half of the nineteenth century following stated medical reservations about the dangers of wearing tight-fitting corsets and incipient moves towards women's liberation, also entered the Viennese fashion world. It is known that the artist and designer Koloman Moser designed a number of dresses for his wife. The Wiener Werkstätten opened its own fashion department in 1911, in which the Viennese style of Reform Movement dress was preferred.

As early as 1906 ten designs were published in *Deutsche Kunst und Dekoration* that are likely to have been by Klimt and Emilie jointly (although they are always described as Klimt's alone). Emilie had the dresses produced in her fashion-house, and Klimt photographed her in them (figs. 32 - 34). The photos were taken for a portfolio that was to be laid out for customers to look through at the fashion-house, presenting them with a collection of exclusive designs. Alongside the innovation of modeling the garments in a landscape setting, a synthesis between reform and fashionable elegance can be seen in the dresses: many have flounces, frills, and high collars.

Klimt's interest in fashion is documented in the dresses he designed together with Emilie, as well as in his depictions of materials, especially during the final period of his work (fig. 35). Emilie is also supposed to have worked for a time on the designs for the *Stoclet Frieze* (fig. 37).[13] Klimt, the painter of ornamentation, found inspiration in Emilie for his artistic work. At that time he always went about in loose-fitting smocks, and there are also personal photographs of Emilie not in elegant dresses but in drooping, sack-like garments that only betray their expensive origins by the patterned material.

32 Emilie Flöge in a summer dress, 1907

33/34 Following pages: Emilie Flöge in a concert dress and in a summer dress, 1907

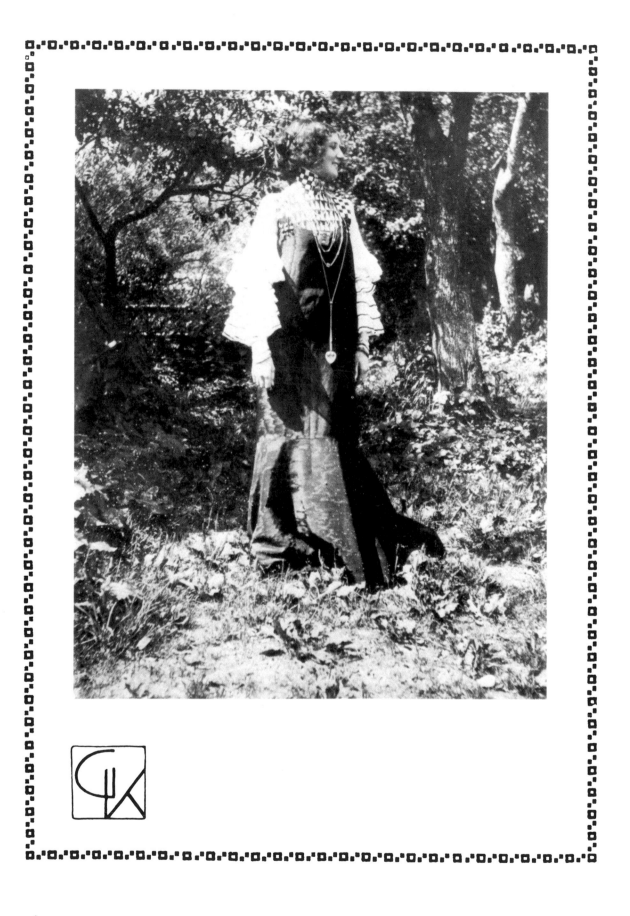

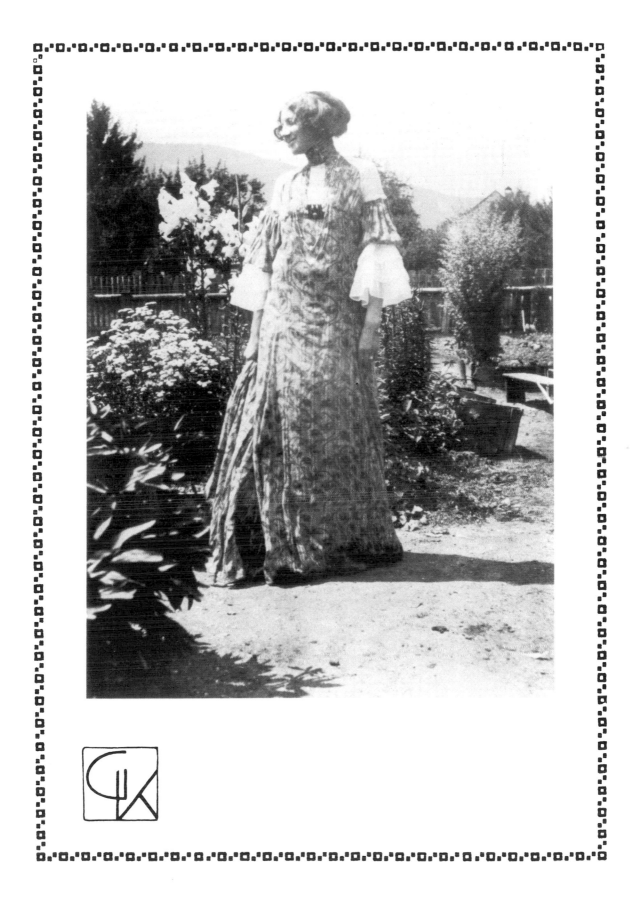

Wearing such clothes corresponded to a new style of life that found its most consistent expression at Monte Verità near Ascona, in the Swiss canton of Ticino, but met with a response in certain intellectual, literary, and artistic circles in most major cities. The reformers propagated a life free from social constraints, similar to the ideas later revived in the hippie movement and the founding of communes in the wake of student protests around 1968. In neither case was this type of reformed life successful, but even at the turn of the century marriage as a bourgeois institution was being called into question. In Vienna, "in the very seedbed of the erotic movement,"[14] alternative ideas of a "free life" were quite virulent. Hermann Bahr, a good friend of Klimt, promoted them and lived them out – and he, too, had a predilection for wearing smocks similar to Klimt's (fig. 36). The ideas of the psychoanalyst Otto Gross (1877-1920), who lived in the Austrian city of Graz, were also influential in Vienna. Gross stood for a liberated, unconstrained form of love, freed from the "shackles of marriage," and free, too, from all jealousy. For Gross, marriage without fidelity was the order of the day. A woman should have the right to conceive children with anyone she wanted, even if she was married. A married man himself, Gross lived with his wife in accordance with these notions. He had many supporters (including women), particularly in the Schwabing district of Munich, and had children by several women, and openly admitted their paternity. The style of the Vienna Secession was a revelation to Otto Gross. He praised its exhibition building, designed by Josef Maria Olbrich (1867-1908), in the highest tones, since he saw it as a realization of the goal of every form of art in a high culture – achieving harmony through simplicity. Klimt, too, admitted the paternity of his numerous children and gave them financial support. The ideas and new lifestyles involving free love had many links with the artistic style of the Vienna Secession.

Alongside the traditional norms that have constantly triumphed, ideas of a "partnership without a marriage certificate" could be put into practice under certain conditions in the metropolises of Berlin, Munich, and Vienna shortly after the turn of the century. The artists Vassily Kandinsky and Gabriele

35 *The Virgin*, 1913

Münter, who lived together in Munich and in Murnau without being married, are an example. To this extent it is conceivable that Emilie Flöge, financially independent of Klimt as she was, preferred a partnership of this type as much as the painter obviously did, particularly since she would probably have had to give up her work if she had become his wife.[15]

36   Hermann Bahr, 1909

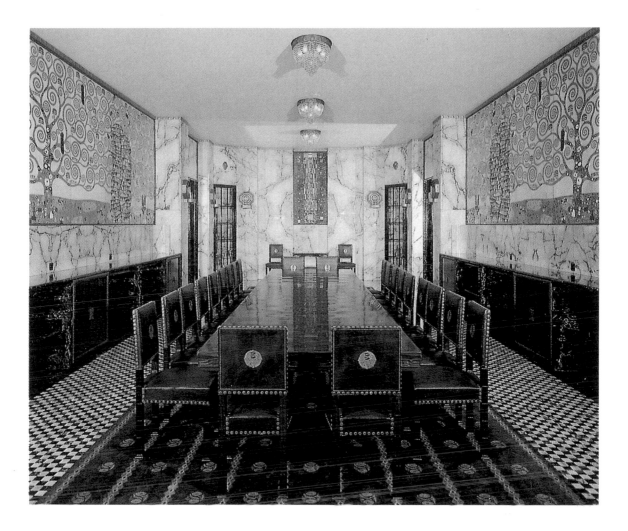

37  *Stoclet Frieze*, 1905-11

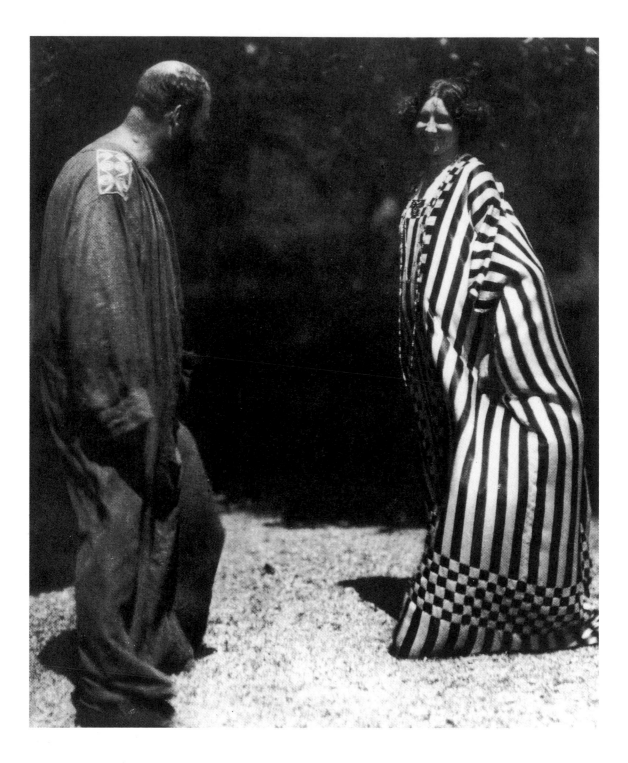

38   Emilie Flöge in a "Reform Movement dress," 1905-06

# The Postcards:
# Evidence of Unfulfilled Love?

Nearly 400 postcards (figs. 39, 40) and the few letters that have been preserved provide further evidence of a close relationship between Klimt and Emilie, one in which each regarded the other with respect. The postcards that came to light in 1983 were found among family belongings, along with items of jewelry that Klimt had given Emilie (figs. 41, 42), a few of her designs, her textiles collection, and photographs, including negatives. After the initial euphoria that greeted the discovery, a sobering recovery followed. Long and heated declarations of love had been hoped for, but short notes, of which most of the 400 items of correspondence consist, were all that were discovered. "Was it credible that Klimt really wrote nothing to Emilie Flöge but the most banal trivialities?" asked the Klimt expert Christian Nebehay: "Most of the notes are reports of Klimt's arrival at one place or other, or of his imminent appearance, or about minor health problems he had.... The most burning question, however – how their relationship stood – remains unanswered. More than that, it is irritating that Klimt found it possible not to write a single endearing word to 'his Emilie'."[16]

Brief, dry jottings do not feature in our romantic notions of love affairs. But Klimt, unlike Oskar Kokoschka, say, had no literary ambitions, apart from the few stumbling verses he composed. He hated writing, as he stated in business letters, for example in the summer of 1905, when he apologized to Karl Wittgenstein for his "pathological inhibition about writing."[17] Nevertheless, it tends to be assumed that he should have written letters such as those Kokoschka sent to Alma Mahler-Werfel. The fact that this large cache of postcards and occasional letters recovered in 1983 is evidence of a very intimate relationship, and one that the correspondents enjoyed on an equal footing, has been overlooked.

Before the telephone became the dominant means of mass communication, it was customary in towns and cities for mail

to be delivered several times a day. Many of the notes Klimt sent
to Emilie on his postcards contain information that needed to
reach her quickly: he cancels a French lesson they were going to
have together, or tells her he has a pair of tickets for the theater.
He writes to her when he forgets there is a Secession meeting,
and asks if he can come at nine for a "little drink" (26 April
1898); three years later, he simply assumes he is always welcome:
"Dear Emilie, I told you I wasn't coming today, but will now be
coming after all. Yours, Gust." (20 December 1901).

Most of the cards were sent when Klimt was traveling, or
were sent from Vienna when Emilie was at Lake Atter, or in
London, or Paris, or at a spa taking a cure. Frequently he wrote
to her several times in one day, telling her how the weather was
and how he was feeling. When he was traveling he wired her to
announce the time of his arrival and asked her to let his mother
know. When Emilie arrived at Lake Atter before him, he
reminded her to note down her "starting weight." Apparently
she always wanted either to lose or to put on weight while she
was there. Klimt knew of such matters in detail. Emilie, too,
knew what he was talking about if he mentioned "the picture."
When she traveled to London and Paris to the fashion shows for
the first time (in 1909), he not only sent her a large number of
cards in which he asked again and again when she would finally
be coming back to Vienna, but also wrote her a long letter

39 Postcard to Emilie Flöge,
July 6, 1908

40  Postcard to Emilie Flöge,
July 6, 1908

(5 March) in which he addresses her as "dear Midi" and looks forward to going for walks with her in the spring. On 12 March, he asks in agitation: "Didn't you leave here too soon, did you need to get to Paris so soon? What if you have to wait about now? Will you maybe wire me when you're coming...." In October of that year Klimt himself went on a long trip via Paris to Spain. From Paris he reports on the 21st: "Here you can dare to wear any kind of costume at all, and no one will raise an eyebrow. You must have liked it here." As well as this reference to Emilie's work and her liking for extravagant dresses, he also tells her about Paris nightlife, which he seems to have enjoyed, and mentions the women there: "...at least a few pretty girls to see there — saw the first young ones at Montmartre (coquettes of course)...." (23 October). In Spain he looked in vain for beautiful Spanish women, and instead dreamt of Emilie. Having returned to Paris, he wrote an extended letter to her on

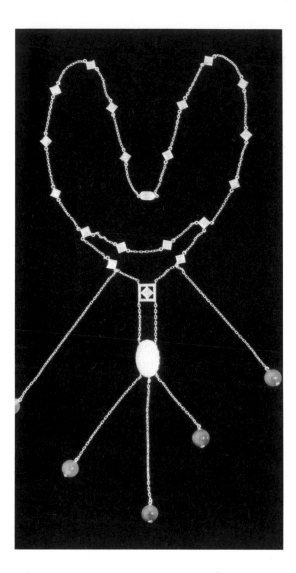

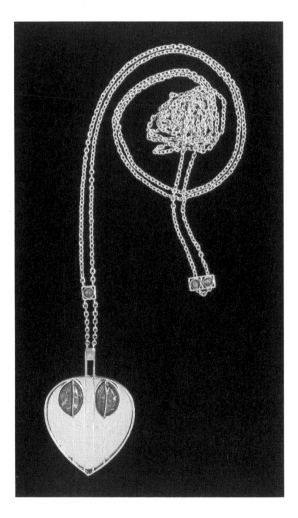

41  Koloman Moser, silver necklace

42  Josef Hoffmann, silver chain
with heart-shaped pendant

2 November in which he again mentioned the dreams he had in Spain, closing by saying: "Now I am pleased as Punch to be returning to my dear silly Midelinchen, Midessa, etc. – maybe she'll come to the station – anyway I'll see her on Thurs." When, for the first time, Emilie went to a spa to take a health cure in 1912, he visited her for a weekend. In 1913 he wrote to her when she was in Paris that they had been invited out together and asked if the date was all right. In another, undated, card he asked her to cancel a meeting with Carl Moll for him.

Emilie was familiar with the details of his life. She made phone calls for him that he hated making himself (e. g. to Carl Moll), and was invited out together with him. Due to their closeness, she could write brief notes to him that were incomprehensible to outsiders: "Do you believe in stupid women? – What a fool!" (11 July 1909). The postcards eloquently delineate the way in which they shared in one another's life, yet each left the other the freedom to act independently. Emilie regularly traveled to Lake Atter each summer before Klimt did, and often only returned to Vienna after him. Self-sacrifice and renunciation are not the terms in which to describe the behavior of a woman who was, at least financially, independent of him. She knew about his love affairs, and about his children. She knew how close he was to his mother and his sisters, the women with whom he lived. For her, a relationship was only possible by maintaining a certain distance, which allowed her to lead an independent life. In this context, Klimt's request, "Send for Emilie," takes on fresh significance.

# Painter and Model:
# Klimt and Mizzi Zimmermann

Following Klimt's death in 1918, the mothers of fourteen illegit-
imate children made claims on his estate. At least three of these
children had been recognized by Klimt himself during his
lifetime. The oldest, Gustav Ucicky (1898-1961), later a film
director, was the son of Maria Ucicka (1880-1928), a
washerwoman from Prague who had modeled for Klimt. He
obviously bore Klimt's name,[18] and only took his mother's last
name as a pseudonym later on. There is an authenticated sketch
of Maria Ucicka's head.[19] It is not known how often she
modeled nude for Klimt.

Klimt had two sons with Mizzi (Maria) Zimmermann:
Gustav (1899-?1978) and Otto (1902-03).[20] On Gustav Zim-
mermann's death, letters and postcards from Klimt to "dear
Mizzi" for the period 1899-1903 were found among his belong-
ings. Nebehay mentions an additional letter, which he was not
allowed to see, in which Klimt explained to Mizzi why he could
never marry her. Nebehay also mentions that the relationship
lasted until Klimt's death. When Klimt moved into a new stu-
dio in Hietzing, she moved there too in order to be near
him.[21]

Also among Gustav Zimmermann's belongings were several
photos (fig. 2) that enable Mizzi Zimmermann to be identified
in drawings and in the painting *Schubert at the Piano* (fig. 44).
Klimt also made a drawing of his baby son Otto on the latter's
deathbed (fig. 43). It shows a child just over a year old, so Otto
cannot possibly have died at the age of three months, as the art
historian Alice Strobl has recently claimed. In addition, two
photos of the boy were found in Gustav Zimmermann's
belongings, with his age, eighteen months, written on them; he
is to be seen standing beside a table.[22]

Klimt wrote most of his letters to Mizzi from Lake Atter.
They are significant in that they allow several landscape paint-
ings to be dated securely at last, and also in that they illuminate

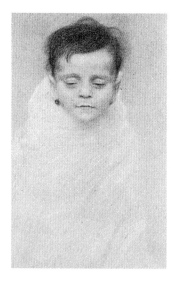

43 Sketch of the deceased Otto
Zimmermann, one of Klimt's
sons, 1903

58

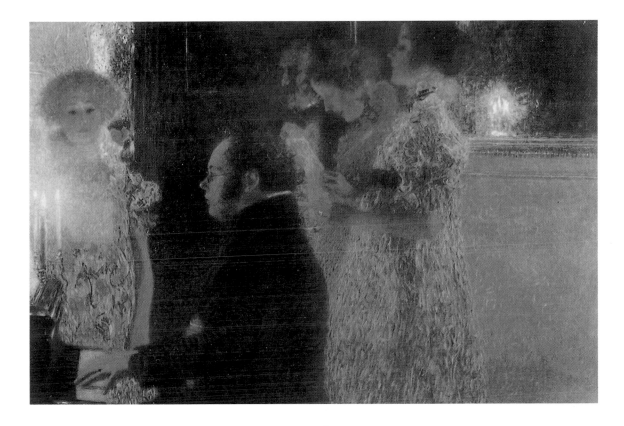

44 *Schubert at the Piano*, 1899. Klimt painted this portrait for the music room in the Dumba Villa

Klimt's methods of working and his daily routine. In 1903 he reported to Mizzi that he had been reading about Japanese art and had been using a "viewfinder," which he described as "a cardboard lid with a hole cut out of it," allowing him "to look for motifs for the landscapes I want to paint."[23] Later he used a small ivory plate for the purpose, or his opera glasses, or photographs. This explains the scrupulously detailed landscape elements that he preferred to make (figs. 45, 60).[24] As to his daily routine at Lake Atter, we learn:

> I get up early in the morning, usually at six, a little earlier, a little later – if the weather's fine, I go into the forest nearby – I paint a beech wood there (when it's sunny) with a few pines mixed in [fig. 46], that goes on till eight, then there's breakfast, after that a swim in the lake, as cautiously as possible – after this a bit of painting again, if it's sunny a painting of the lake, if it's dull a landscape from the window of my room – sometimes there's no morning painting, instead I study my Japanese books – outdoors. So it goes

on till noon, after lunch I have a little doze or do some reading –
until snack time – before or after the snack I go for a second swim,
not every day but most. After the snack there's more painting – a
big poplar in the twilight in a gathering thunderstorm [fig. 47] –
now and then instead of the evening painting we have a little bowls
match in a village nearby – but rarely – twilight comes – supper –
then early to bed and up again early next morning. Now and then
there's some boating [fig. 6] added to this timetable to shake up the
muscles a bit.[25]

Klimt's biographers describe his letters to Mizzi Zimmermann
as affectionate and tender, evidence of his great love for her. In
contrast to this, he is said never to have sent Emilie a single
warm or affectionate word. With Mizzi he was eager to com-
municate, describing his worries as a painter and other things
that were weighing on his mind. But the letters to Mizzi have a
quality of condescension: he laboriously describes to her why he
is sending money by the normal post and not by registered mail,
and addresses her as "child"; nor does the fact that he has added
a "kiss" (*Kuss*) to his farewell (*Gruss*) at the end of a letter show
any evidence of ardently declared love. But he seems to have
taken care of his children, writing, for example, to "Gusterl" on
his birthday and often asking after him.

None of this would be of any interest if the correspondence
with Mizzi could not be compared to the letters and cards to
Emilie, the very brevity of which is, paradoxically, evidence of a
greater intimacy. From Brussels, where he was examining his
*Stoclet Frieze*, he sent Emilie very detailed descriptions of how he
was. The intensity of his relationship with Mizzi is interesting
above all because on the two occasions when she was pregnant
by him, Klimt incorporated the theme into his paintings.

The best-known example of this is *Hope I* (fig. 49), a painting
of a completely naked pregnant woman. In the Vienna *Arbeiter-
zeitung* of 15 August 1953, Arthur Roessler published "Klimt and
his Models," a story about the painting's creation that has been
assumed to be true ever since, although it was written half a cen-
tury after *Hope I* was painted. Klimt is alleged to have asked after
a model who had not been to him for a long time, and when he
heard that she was pregnant and didn't dare to visit any more, he

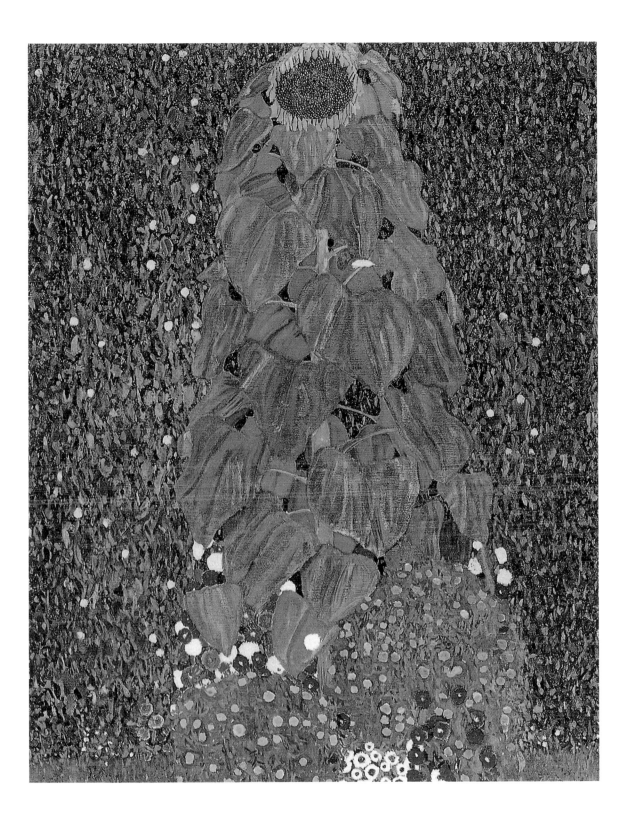

45  *The Sunflower*, 1907. Detail

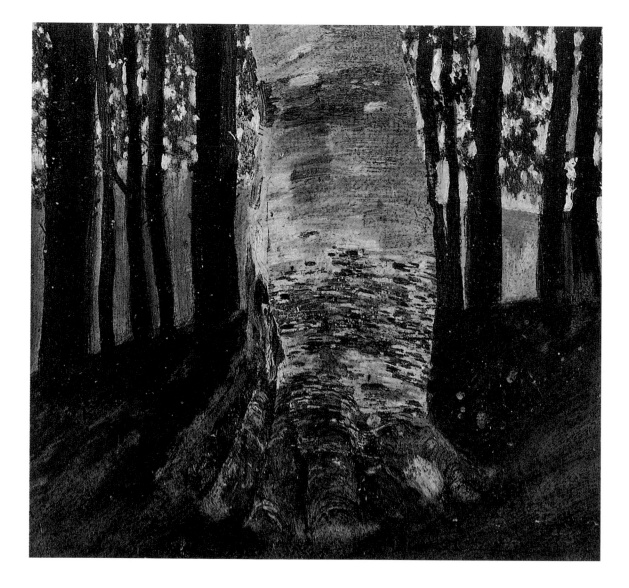

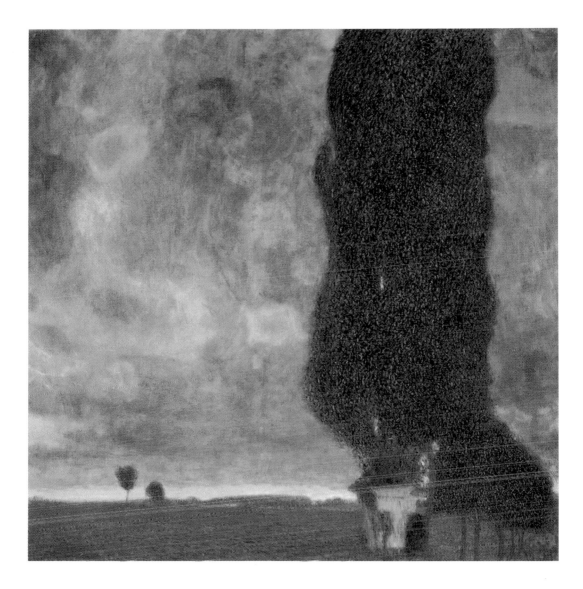

47   *The Big Poplar II*, 1902 – 03

46   *Beech in a Forest*, ca. 1903

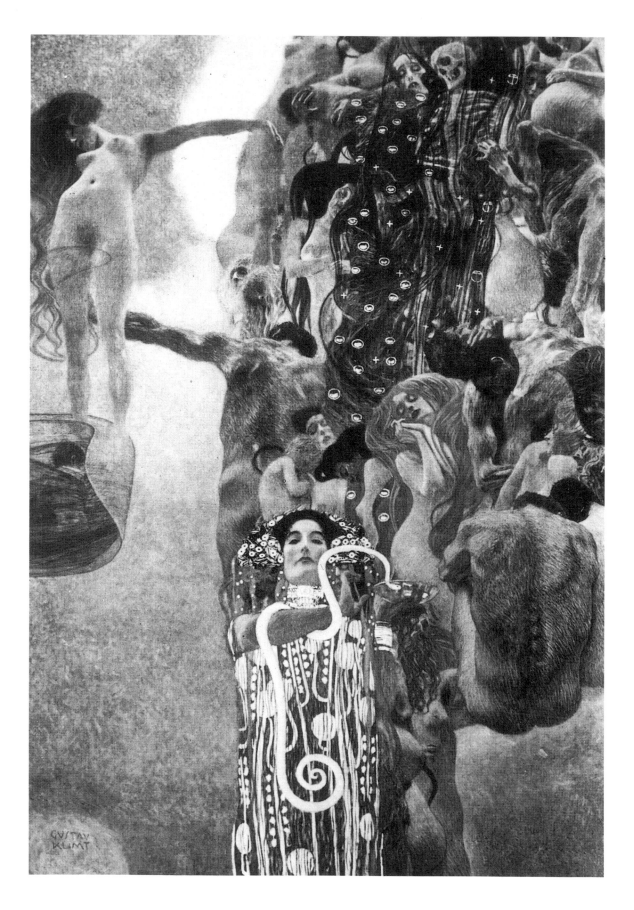

insisted that she come in order that he might paint her. *Hope 1* is the result. Against this version, however, there stands the fact that Klimt produced many drawings of pregnant women, dating from various years. He painted a pregnant woman three times, first in *Medicine* (fig. 48), completed in 1907, then in *Hope 1*, and in 1907-08 in *Hope 11* (fig. 51).

In *Medicine*, one of Klimt's paintings for the Great Hall of Vienna University, and in *Hope 1*, the pregnant woman is shown in a similar pose. The body is seen in profile, so that the full curve of the stomach can be seen in its entirety. She has folded her hands over the start of the curve, a typical posture of a pregnant woman. In *Hope 1*, the woman, whose head is framed by ample red hair, looks out of the picture at the viewer, as in the portrait of Emilie Flöge (fig. 25). Her slim legs, her well-shaped buttocks, and red hair convincingly present the image of a *femme fatale*. However, her stomach, the evidence of her pregnancy, disturbs this impression. The woman's natural pose and the realism of the depiction suggest that Klimt has incorporated into the painting experiences extending beyond brief observations; this brings us back to Mizzi Zimmermann.

In 1896 Klimt was commissioned to produce three of the faculty paintings for the hall of Vienna University.[26] The second painting, *Medicine*, finished in 1901, includes the pregnant woman, or rather her stomach and her hands, at the upper edge of the work. In 1899 he had used Mizzi Zimmermann as his model for the painting *Schubert at the Piano* (fig. 44). In the same year their son Gustav was born. In the sketch of the composition for *Medicine*, the pregnant woman has not yet been incorporated into the picture. It is quite possible that Klimt had the idea as a result of Mizzi's pregnancy. In 1902 Mizzi became pregnant for the second time, and Klimt turned his attention to the topic again, as drawings of the period show. She now modeled for *Hope 1* – although he altered the face. His original concept for the painting had been different. The background was initially to have been a landscape, and then a patterned carpet, either of which would have better suited the subject.[27] The version that was executed is strikingly different: the pregnant figure stands in front of a length of blue material interwoven with

48  *Medicine, 1900-07*

gold, a symbol of hope. However, behind it are grim reminders: the giant Typhon appears, the larger-than-life figure to be seen in the *Beethoven Frieze* (fig. 50), and at the left upper edge three grotesque faces and an eyeless skull are present. Two of them can certainly be read as Sickness and Death, and the other two are perhaps Misery and Crime, or Madness and Grief. Klimt had already included personifications like these in the *Beethoven Frieze*, describing them as "the malevolent powers: the giant Typhoeus [Typhon], against whom the gods themselves struggled in vain; his daughters, the three gorgons. Disease, Madness, Death. Lust, Unchastity, Excess. Devouring Grief."

It is possible that Klimt took the decision to redesign the background in *Hope I* after the loss of his son Otto, in that Otto's death persuaded the artist to alter it. Born in June 1902, Otto is thought to have died in October of the same year. But in a letter of August 1903 Klimts asks after "little Otto" (*nach dem kleinen Otterl*),[28] and this would correspond in terms of age with the drawing of the boy after his death (fig. 43). Strobl suspects that *Hope I* was completed around 1904. If Otto died in October 1903 (i.e. if "1902" was a slip of the pen), then late 1903 or 1904 seems likely. Mizzi Zimmermann's second pregnancy had inspired Klimt to take up the topic once again. The positive aspects of birth that the title *Hope I* suggests are shattered by the son's death. In a condensed form, Klimt's philosophy of life – as depicted in a more extended fashion in the *Beethoven Frieze* – is translated into the picture. Longing for happiness is indicated in the blue material behind the pregnant figure. But the achievement of happiness (seen in the *Beethoven Frieze* in the finale, "This kiss is for all the world"; fig. 63), the real climax, is lacking.

The subject of the painting for Klimt is his personal experience with pregnancy and death. But in the present context the painting is also evidence of Klimt's image of woman. Woman – in this case Mizzi Zimmermann – is degraded to the status of an object, in much the same way as Otto Weininger degraded women in his book *Sex and Character* (*Geschlecht und Charakter*), published in Vienna in 1902.

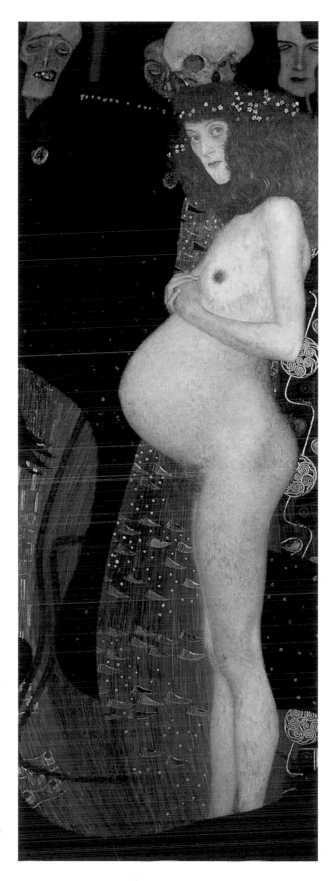

49  *Hope I,* 1903

50 "Malevolent Powers," detail of the *Beethoven Frieze*, 1902.
From left to right: the three gorgons Disease, Madness and Death,
the giant Typhon, Lust, Unchastity, Excess and Devouring Grief

In the second version, *Hope II* (fig. 51), the subject has been deprived of its focus. The woman's body is veiled by a gown that is covered in ornamental spirals. Over this gown is a bright red coat decorated with golden circles and colored dots. Only the woman's breasts are exposed. Seen in profile, her eyes are closed and her head is lowered, but her raised hand indicates that she is not in fact asleep. Three women at the lower edge of the painting repeat the gesture. From their physiognomy, they seem to be triplets. Even the death's-head intruding into the picture at the edge of the woman's distended stomach is not so much a threat as an accessory. Whether Klimt painted from life again in this case is not known. However, it is clear that Klimt took Mizzi Zimmermann for his model, a woman who was financially as well as emotionally dependent on him. The fact that he did not include her own face may show a remnant of respect, but may also have been motivated by a desire not to expose himself.

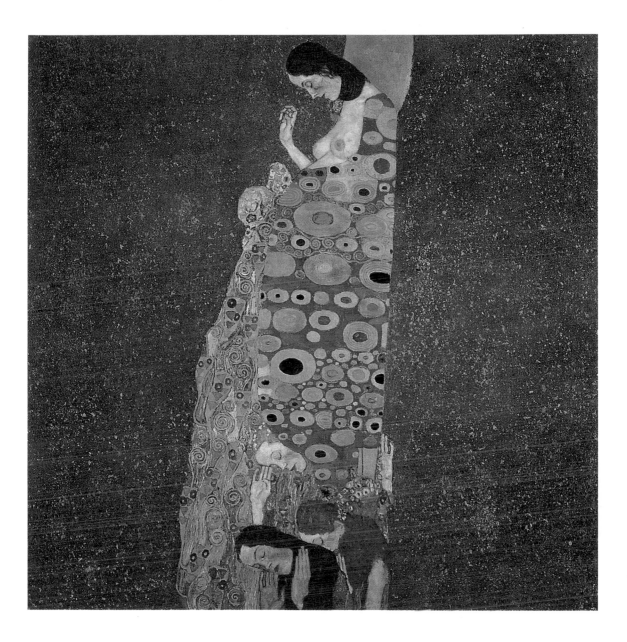

51 *Hope II*, 1907 - 08

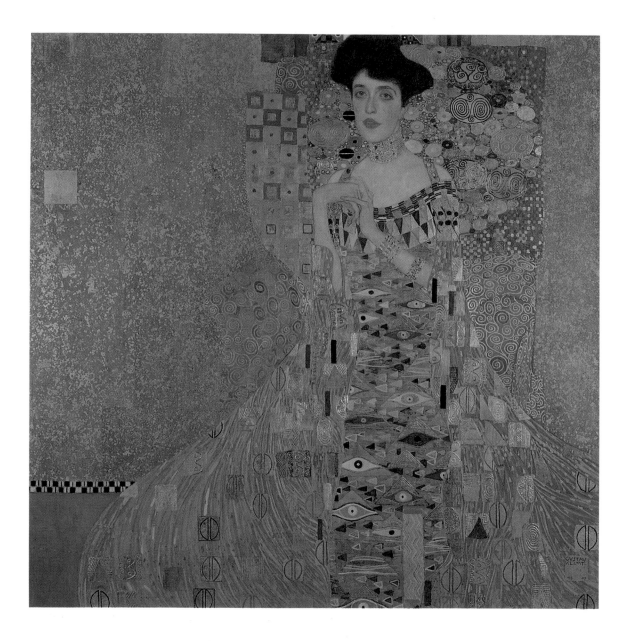

52   *Portrait of Adele Bloch-Bauer I*, 1907

# Klimt and Alma Mahler-Werfel

In her autobiography Alma Mahler-Werfel (1879 - 1964), step-daughter to Klimt's friend Carl Moll, describes the love affair between Klimt and herself, the only fulfillment of which, she says, took the form of a kiss in St Mark's Square, Venice. She says this occurred in 1897. However, two postcards to Emilie Flöge, dated 2 and 6 May 1899, and Klimt's letter of apology to Carl Moll of 19 May 1899, which has since been published, show that Alma Mahler was in error by two years.[31] Klimt's letter of apology to Moll is the longest written document by him that has been preserved, and it contains interesting evidence of his character and of his attitude to women. Fearing for his friendship with his fellow painter, he went into considerable detail in his explanations. After some initial soothing phrases, such as "You are seeing things much more grimly than they actually are as a result of your paternal cares," he described his contacts with Alma:

> Alma has often sat next to me, and we talked together without any harm....I have never courted her in any real sense — and even if I had, I would never have expected any success, there were many gentlemen coming to the house paying their addresses to her — I have had false suspicions of her and labored under misapprehensions...
>
> It was only very recently — the trip to Florence had already been decided on — that I noticed various things, the young lady must have heard a few things about my affairs, a lot of it true, much of it false,
>
> I don't know everything about my affairs myself and don't even want to — but there's one thing I am sure of — that I am a poor fool — to cut a long story short, from suggestive questions and remarks it seemed to me that the young lady was not entirely indifferent to these matters, as I had thought at first. This rather scared me, as I have nothing but awe and respect for true love, and I came rather into conflict with myself, in conflict with my true feelings of friendship for you, but I consoled myself with the thought that it was just a little game on her part, a mood. Alma is beautiful, intelligent, and

witty, she has everything a discriminating man could require of a female...but even as a game it seemed dangerous to me, and it would have been my job to be sensible, as I have more experience, and this is where my weakness begins.

In what follows, Klimt writes that he doubted whether he and the Moll family ought to go on a trip together to Italy because of these feelings that he had, but he followed the Molls there nevertheless. He and Alma were kept apart as much as possible – and he didn't fail to notice this – but they were able to have conversations nevertheless. These, he says,

> were warm and friendly, but for the most part far from approaching anything that could be described as courting. It was quite clear to both of us that it was "thus far and no further." So back. The path to wrong should not be gone down. There was no choice.

53  Study for *Judith 1*, ca. 1899

54  *Judith 1*, 1901

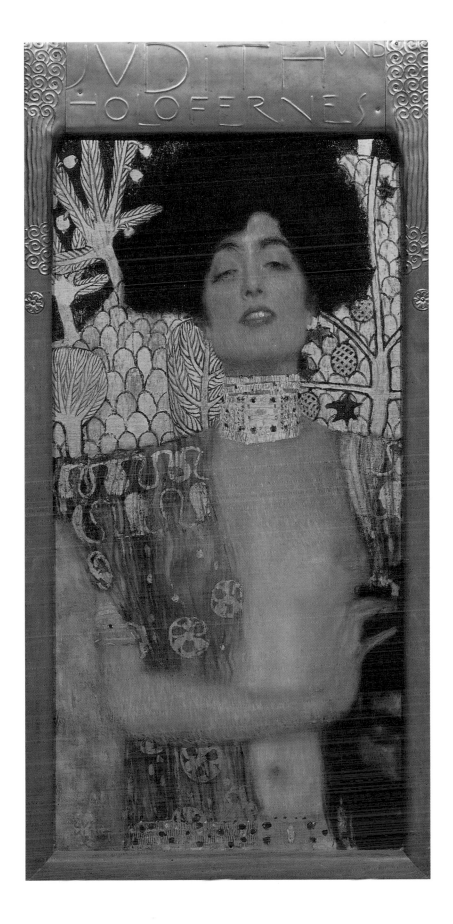

Then that evening in Venice came. I am an embittered person, and this sometimes expresses itself in malice that is not without its dangers, which I deeply regret afterward. So it was here as well. I had been drinking rather more quickly than was wise, I'm not trying to excuse myself here – what I said was rather more careless than it usually is, and this was probably what you heard, and from which you drew your own conclusions, which are certainly too wicked, too black....Dear Moll, forgive me if I have caused you trouble, I beg your dear wife to forgive me and Miss Alma, I don't think it will be difficult for her to forget about it.[32]

55 *Portrait of Fritza Riedler*, 1906

The letter reveals the relationship Klimt had to women that also finds expression in his paintings and drawings. A "discriminating man" (such as himself) expects from a "female" (*Weib*) that she should be "beautiful, intelligent, and witty" – and, in addition, available. Alma had given him to understand that she knew about his affairs with women. And for Klimt, who thought that she was playing with the feelings of the men who came and went in her stepfather's house, she was nothing more than a young woman who would not be averse to a little "game." He gives no further thought in the letter to Alma's feelings: "I don't think it will be difficult for her to forget about it"; instead, he is more worried about his relationship to Carl Moll. In her autobiography, by contrast, Alma Mahler-Werfel speaks of many tears and months of self-torment, although she describes Klimt in retrospect by saying, "He was tied down at a hundred points: women, children, sisters, who out of their love for him became enemies to one another."[33] But she also wrote that "He was quite accustomed to playing with human sensitivities," and that "He had no one around him but worthless females – that was why he sought me out, because he felt that I could have helped him."

Alma Mahler-Werfel wrote her autobiography in 1960. She may have forgotten many details (as the incorrect dating of the trip to Italy indicates), and may not have been aware of others. For, in addition to "worthless females," as Alma Mahler saw women such as Mizzi Zimmermann, in the same year as he was making eyes at Alma he began a liaison with the wife of the banker and sugar manufacturer, Adele Bloch-Bauer, whom he immortalized in *Judith 1*.

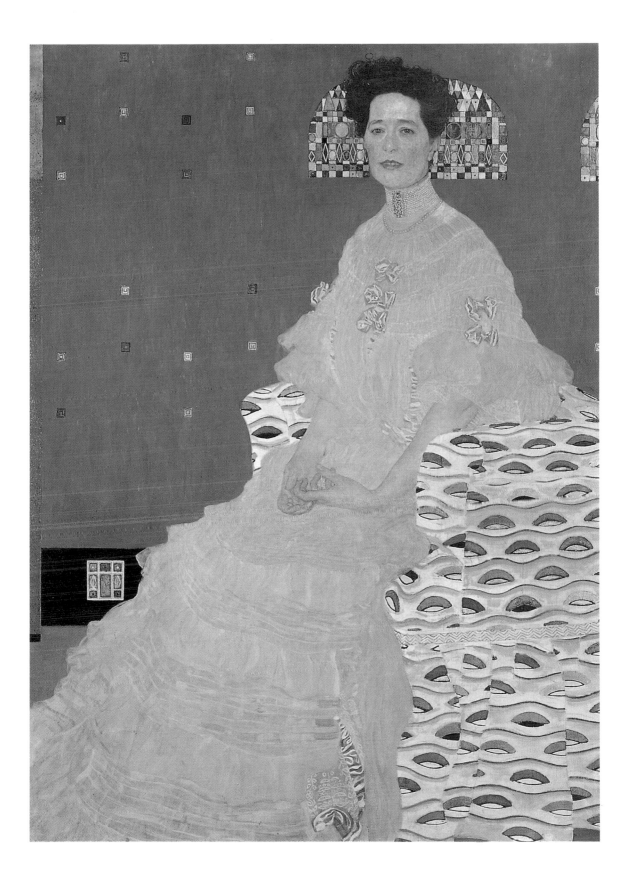

# Painter and Client:
# Klimt and Adele Bloch-Bauer

Adele Bloch-Bauer (1882 - 1925) came from a wealthy Viennese banking family, and while still young married the very much older banker and sugar manufacturer Ferdinand Bloch (1864 - 1945/6). The Blochs were collectors of Klimt's work, and in addition to the two portraits of Adele Bloch-Bauer they also purchased four of his landscapes.

Adele Bloch-Bauer (fig. 52) was the only society lady who was painted twice by Klimt. The initial preliminary sketches for the first portrait of 1907, the most famous one of the "Golden Period," date from as early as 1900. Klimt thus allowed himself seven years to complete it. It is now known that Klimt had been involved in a relationship with Adele since 1899, and that she was his model not only for the two portraits, but also for the two depictions of *Judith* (figs. 54, 56). But the similarity of the facial features of the female in *Judith I* and Adele Bloch-Bauer was also recognized independently[29] of the publication of Klimt's "final secrets," which took place in a rather obscure journal.[30]

Two oft-repeated speculations are, therefore, no longer tenable. First, Klimt selected his models not only from members of the lower social classes offering modeling services at the Academy; second, he satisfied his sexual appetite not only with these lower-class models but with high-society ladies as well. His advances were not always successful, however, as the example of Alma Mahler shows.

The woman in *Judith I* (fig. 54), often also referred to as *Salome*, is placed in front of a background formed by golden trees and a fish-scale pattern framing her head. At the left of the painting a greenish-blue background shines through. The woman's black hair is overlapped by the picture's upper metalwork frame, on which the words "*Judith und Holofernes*" appear, and she looks out at the viewer lasciviously through half-closed eyes. Her neck is adorned by a broad golden band studded with jewels, similar to one in the possession of Adele Bloch-Bauer (fig. 52). However,

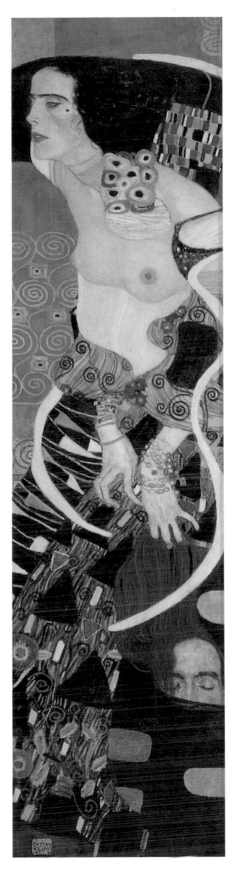

56 *Judith II*, 1909

this one is not a pearl choker, but has a rigid, martial shape. A green cloth hangs from her right shoulder and covers one breast. Her otherwise naked torso is clothed from just below the navel – with a golden belt that is overlapped by the lower frame. Her right hand is reaching towards the head of Holofernes, whose face is half covered by the right side of the frame. Klimt painted not the active Judith familiar from numerous paintings, not the Jewish woman who cuts off the besieger's head after beguiling him and getting him drunk. Gottfried Friedl has observed[34] that the threatening quality emanates from the woman herself as a *femme fatale*. As we now know, Klimt knew the woman in the painting, and any interpretation of the work must be complicated by that personal element. Klimt was fascinated by the woman, and at the same time feared her. From Klimt's point of view, she wants to cut off his head, the very head she then caresses. This is a Judith who does not hold the head of Holofernes by its hair; nor is she holding the head merely incidentally. She has laid her hand on his head tenderly and is caressing it. Klimt has made his fear of the woman and his simultaneous fascination with her the subject of the painting. The painter's personal relationships, although he always tried to keep his private life out of the limelight, can therefore be read out of his work to a much greater extent than has yet been thought. The Viennese public of the time knew this, as a comment of 1903 on *Judith I* by the writer Felix Salten (1869-1945) shows:

> The modern element of Klimt's work can be seen in detail in his Judith: he takes a present-day figure, a lively, vivid person the warmth of whose blood can intoxicate him, and transposes her into the magical shadows of distant centuries, so that she seems enhanced and transfigured in all her realness. One sees this Judith dressed in a sequined robe in a studio on Vienna's Ringstrasse, she is the kind of beautiful hostess one meets everywhere, whom men's eyes follow at every première as she rustles by in her silk petticoats. A slim, supple, pliant female, with a sultry fire in her dark glances, cruelty in the lines of her mouth, and nostrils trembling with passion. Mysterious forces seem to be slumbering within this enticing female, energies and ferocities that would be unquenchable

57 *Portrait of Adele Bloch-Bauer II*, 1912

if what is stifled by bourgeois life were ever to burst into flame. An artist strips the fashionable dresses from their bodies, and takes one of them and places her before us decked in her timeless nudity.[35]

Salten clearly emphasizes the fact that Klimt has here taken a close confidante from the upper reaches of Viennese society as his Judith.

Adele is wearing the "sequined robe" from "a studio on Vienna's Ringstrasse" in the portrait he painted of her. This principal work of Klimt's "Golden Style" (fig. 52), completed in 1907, is the only picture in which he makes the subject of the portrait vanish entirely into the gold. In comparison with the portrait *Fritza Riedler* (fig. 55), produced a year earlier, clear differences can be seen. Fritza, in a white dress, is sitting in an armchair in front of a background consisting of several colored surfaces that can be seen as a wall and a floor. At the left edge of the painting a golden bar enters the picture. In the portrait of Adele Bloch-Bauer, by contrast, only the head, shoulders, arms, and hands seem to emerge from the golden, ornamented surface. At first glance, the body remains concealed. It is only with an effort that a leather armchair and the dress covered with eyes appear. The figure's seated posture can only be guessed at from the way in which the arm leans on the armrest. To free himself from her, Klimt has composed Adele Bloch-Bauer into the gold, has captured her in it and stylized her into an object. But he is also paying homage to her, for if the portrait relates to Byzantine icons of the Madonna more closely than any other portrait type, he uses the motif of the open almond, spreading in several squares across the armchair, to convey a playful reference to the sexual element of their relationship.

It is hard to judge from the face whether Adele Bloch-Bauer was also the model for *Judith II* (fig. 56). This Judith has nothing in common with the seductress of 1901. As with the two paintings of *Hope* (figs. 49, 51), the later version does not have the same acuity. Dressed in a long robe that leaves only the breasts exposed, this Judith is gazing downward with half-closed eyes. Seen from the side, she has no direct contact with the viewer. Inwardly engrossed, she seems to be dancing, an impression reinforced by the alternative title "Salome," which continues to

58  *Portrait of Rose von Rosthorn-Friedmann, 1900–01*

be used erroneously. The head of Holofernes is now in a sack. She is digging the fingers of one hand, with which she is also gathering her dress, into his long hair. The "castration" of the man is forever complete.

Three years later Klimt painted a further portrait of his (former?) mistress (fig. 57). Placed in front of a colorful, ornamental background, enriched in its upper portion by the Japanese motif of galloping ponies, the woman in her long dress is nevertheless not permitted to have a body. The figure's similarity to the early Judith is clear from the face. But there are no sexual symbols to suggest a relationship of any kind. Did Klimt intend to show up Adele Bloch-Bauer through an obvious comparison with the earlier *femme fatale*? Or was this an act of homage to a woman he still admired?

Klimt clearly integrated several of the society ladies whose portraits he painted into his depiction of the *femme fatale*. One example that is now known is the long-lost portrait *Rose von Rosthorn-Friedmann* (fig. 58), dated to before 1901. This lady of the Viennese aristocracy was considered to be not only beautiful, but also extremely intelligent. Klimt used her face again, with the figure in a similar posture, in his *Water Nymphs* (fig. 59). The latter painting, first exhibited in 1903, was obviously produced at the same time as the portrait, and was probably only released in 1903 in order not to endanger the well-paid commission: it is not always certain that these "loans" took place with the permission of the portrait's subject; and it is also not clear whether Klimt had love affairs with all of those concerned. These "loans" seem to have been the subject of some discussion in Vienna at the time.

In 1985 Fliedl[36] pointed out that Arthur Schnitzler (1862-1931) immortalized Klimt in literary form as the painter Gysar in his *Comedy of Seduction* of 1923, but does not go into the matter in any further detail. Schnitzler not only describes Klimt's studio in the play – "My house stands alone, and there are high walls round the garden," he adapts for another image the shrine that Fritz Waerndorfer had produced for the painting *Hope I*, and makes references to Klimt's mistresses and their portraits. "As you may well know, he has painted all of his mistresses, well

59  *Water Nymphs (Silverfish)*, ca. 1899

– just as Correggio painted Io, when the cloud descended on her. And he is always the cloud." At the very beginning of the comedy, there is the following remark on society ladies and their portraits: "Don't you know that he paints two portraits of every woman that models for him? One is the official one, fully dressed, and then there is the other."[37] In Schnitzler's version, this "other" was a Venus with the face of the Princess von Degenbach, which was to be exhibited in the Moderne Galerie.

Even if Schnitzler – who held Klimt in great respect and owned at least one drawing by him – was exaggerating, these passages are a further indication that during Klimt's lifetime a great deal was known about him in Vienna. Adele Bloch-Bauer does not seem to have been an isolated case.

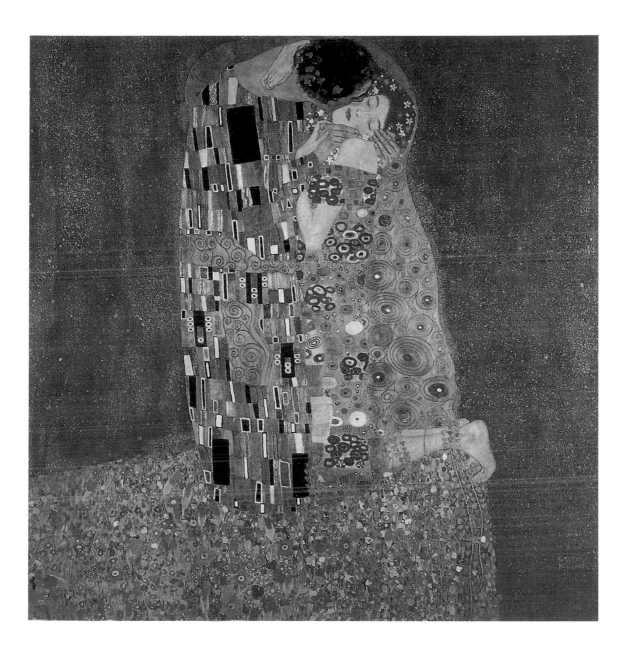

## The Kiss

No consideration of Klimt would be complete without a discussion of *The Kiss* (fig. 60), his most famous painting. After Strobl suggested that there was proof that *The Kiss* depicted Emilie and Klimt himself, Grimberg claimed the painting for Adele Bloch-Bauer.[38] But the work itself makes exact identification impossible, even though Klimt, in a sketchbook of 1917 (!) took up the

60   *The Kiss*, 1907–08

87

subject again and wrote "EMIL[I]E" in large letters on the left side of his sketch. This sketch may be a design for an unexecuted brooch.

Klimt had already been occupied for a considerable time with the subject of lovers united by a kiss. In 1895 he painted an early version of *Love* for the portfolio publication *Allegories and Emblems*. A pair of lovers are linked in a wide gold frame adorned with roses. The man bends down towards his lover, who waits with closed eyes for the approaching kiss. The action of the man, whose body is veiled by a bush, is softened by the way in which his face is in shadow, but the woman's surrender to him is clearly recognizable, her face lit from a source that is not defined. But the lovers are not alone. At the upper edge of the picture the heads of women emerge from the haze: the child at the center with a brightly shining face is accompanied on the right by a young woman and an older, mask-like face, while on the left a toothless hag gawks down at the lovers out of her deep eye-sockets, and is accompanied by Death and the grotesque faces that Klimt used again in *Hope I* (fig. 49). Love, the privilege of youth, is threatened by age, hatred, envy, and death. The painting anticipates in a condensed form the statements Klimt was to return to in *Philosophy*, one of the faculty paintings (fig. 61), later concealing them in an orgy of gold in the *Beethoven Frieze* (fig. 63) and the *Stoclet Frieze* (fig. 64), where the ornamentation assumes the erotic function.

In *The Kiss* the lovers are embracing in a flowering meadow. The man, whose body is entirely shrouded in a garment covered with rectilinear ornamentation, is bending to the kneeling woman, who seems to be disappearing into him. Her golden dress, set with colored discs, is close-fitting, and, in contrast to dresses to be seen in contemporary portraits of women, allows the contours of her body to be guessed at. Her bare feet are pressed against the edge of an abyss. The aura behind the couple completes the outline of the man's body, and ends directly at the woman's ankles, which are not within this protected area. Her face is turned towards the viewer. She, too, is waiting with closed eyes, like the woman in *Love* of 1895, for the approaching kiss. It would be risky to claim that Emilie Flöge's facial features

61 *Philosophy*, 1899-1907

88

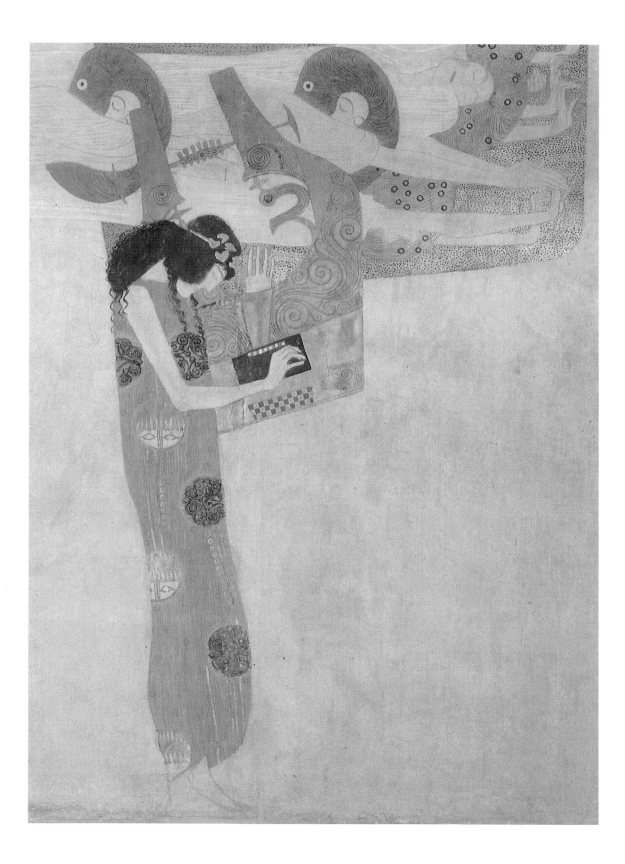

62  "Longing for Happiness Finds Repose in Poetry," detail of the *Beethoven Frieze*, 1902

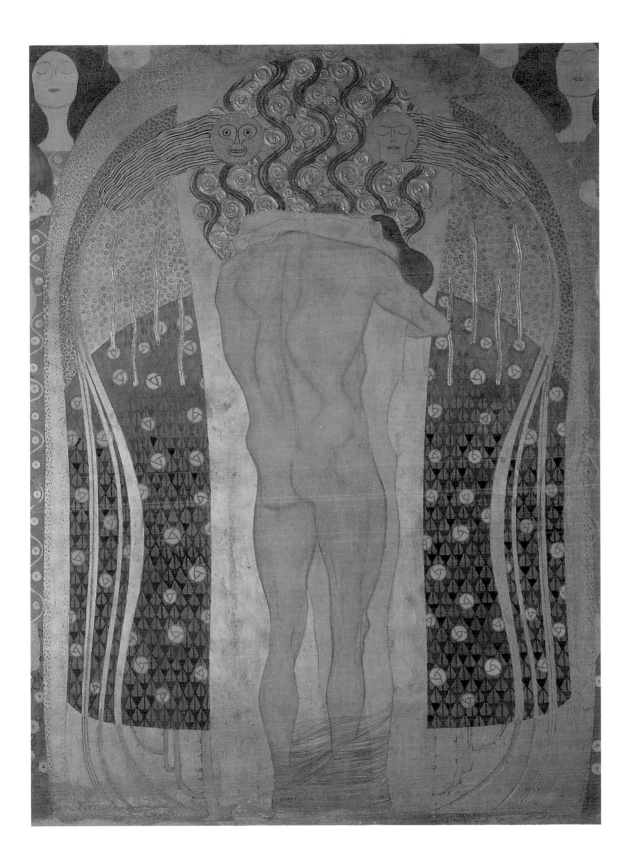

63 "This Kiss Is for All the World," detail of the *Beethoven Frieze*, 1902

can be recognized in her; the elegantly proportioned face resembles many of the women Klimt painted, for example in *The Virgin* (fig. 35), *Death and Life* (fig. 65), and, above all, the young woman in *The Three Ages of Woman* (fig. 66).

Klimt exhibited *The Three Ages of Woman* of 1905 along with *The Kiss* at the 1908 *Kunstschau*. The paintings are both 72 x 72 " in size and share a similar structure. Like the lovers, the three figures stand out in front of an aura and leave considerable space free to both right and left. The passive role of woman and the dangers arising for her in the course of growing older are displayed. The old woman, with her ugly, emaciated body, has turned away, and her long gray hair and her left hand cover her face. Her stomach is slack from giving birth, her breasts hang down. The young woman beside her has her face turned aside in the same way as the woman in *The Kiss*. She seems to be sleeping, as is the child in her arms. Her nudity is partially shielded by a blue, transparent veil, and one of the child's feet and the veil cover her groin.

If these two paintings are seen as a diptych, their message is the same as that of *Love*. The masks at the top of the picture, like the figures in *The Three Ages of Woman*, represent women. They contradict the concept of happiness that seems to be manifested in *The Kiss*, and one visualizes the abyss to which the lovers are dangerously close. The disparateness of the implicit relationships to woman (*Three Ages*) and to love (*The Kiss*) emerges when the two paintings are viewed together. Any identification with Emilie Flöge would be extremely unflattering to her.

64 "Fulfillment," detail of the *Stoclet Frieze*, 1905-11

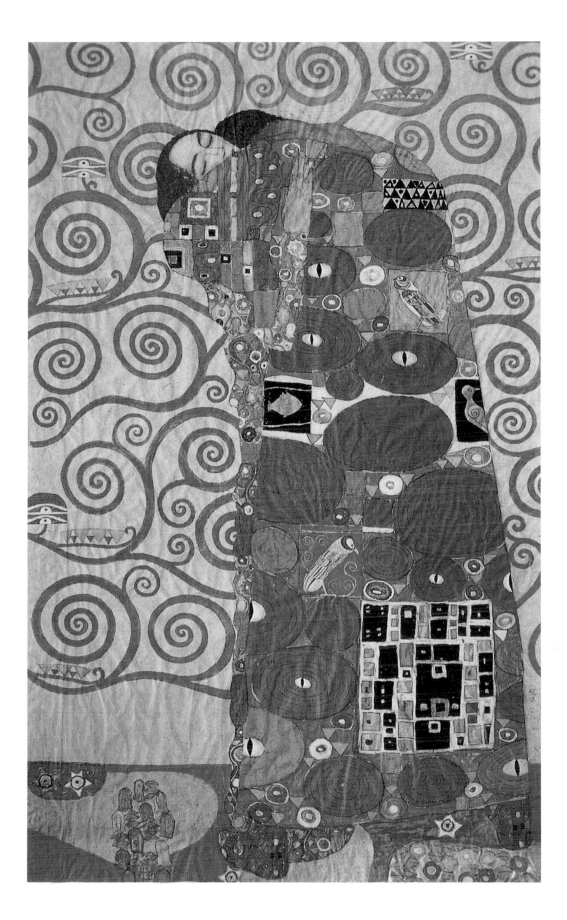

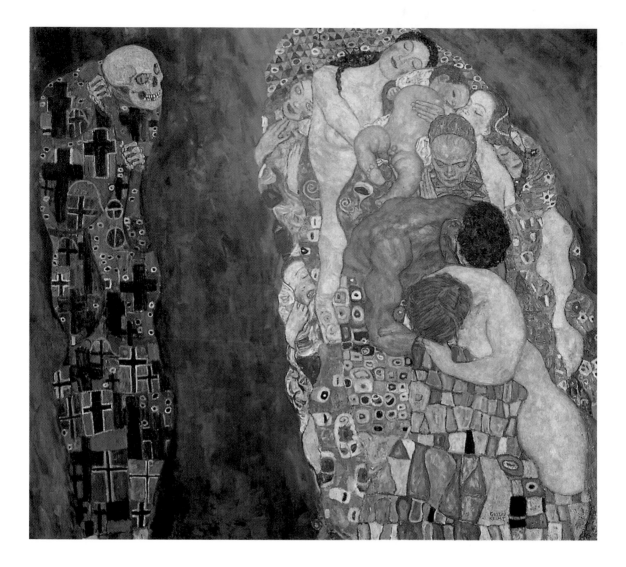

65  *Death and Life*, before 1911

66  *The Three Ages of Woman*, 1905

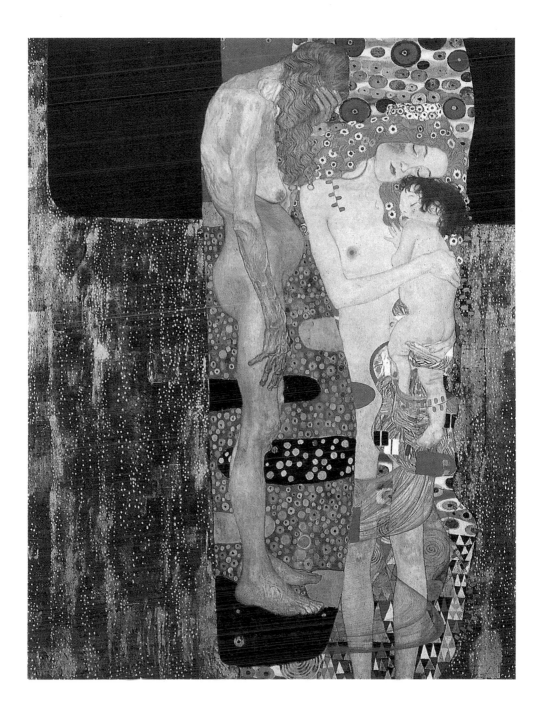

# Klimt and His Models

There are conflicting reports about Klimt and his models in the studio, but this is true of his life in general. A painting made by his friend Remigius Geyling (1878-1974) around 1902 (fig. 67) shows Klimt transferring the sketches for *Philosophy*. The painter is sitting on a framework in one of his smocks. His feet hang down, and he supports himself with one hand while the other pauses in mid-stroke as he turns to look behind him. There a nude woman with red hair is standing on the table and handing Klimt a tray with a glass of wine, a piece of cake, and some fruit while another girl is attempting to climb up the ladder to reach the painter. While one can assume that Geyling put an element of exaggeration and caricature into his watercolor, there are some contemporary descriptions of Klimt's studio, for example one by Franz Servaes, that correspond to the painting: "here he was surrounded by mysterious female beings who, while he sat silently in front of his easel, were wandering up and down in his studio, lolling and lazing about, taking life easy — always ready at a mere sign from the master to freeze obediently as soon as he spotted a pose, a movement, and his sense of beauty was stimulated to record it for a moment in a quick sketch."[39] Schnitzler also mentions models awaiting a sign from him.[40] It has been inferred from the sentence, "One or more models were always waiting in the outer room so that he would continually have alternating models for the infinite variations on the theme of 'woman' at his disposal,"[41] that Klimt could only work "in complete silence and without disturbance." For this reason the two models in Geyling's painting were seen as "an affectionate invention of Geyling's,"[42] and were not thought to correspond to reality at all.

But the report by Servaes, as well as the material in Schnitzler's *Comedy of Seduction*, are there as evidence from Klimt's lifetime, or from shortly after his death, and were not written by his enemies, but by his friends. The many drawings he made, of which those that have been preserved (over 4,000)

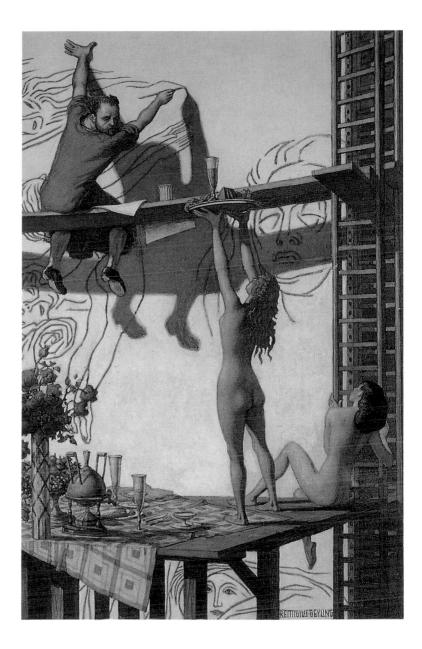

67 Remigius Geyling, *Gustav Klimt Transferring the Sketch for His Faculty Painting "Philosophy,"* ca. 1902

probably represent only a fraction, have woman in all her erotic facets as their subject. The drawings, which Klimt did not publish during his lifetime, must today form the starting-point for any description and interpretation of his image of woman, no matter how much these descriptions and interpretations may vary. Critics speak of the emancipatory feelings of woman that he transposed into his paintings, of his fears of castration or impotence, of the total availability of the women concerned. All of these interpretations seem to have some element of legit-

imacy. Klimt produced paintings of woman as aggressive (*Pallas Athene*; fig. 68), as a *femme fatale* (*Judith 1*; fig. 54), and as an object of desire (*Danaë*; fig. 70). In his portraits he deprived woman of her body and her intellect (*Margarete Stonborough-Wittgenstein, Adele Bloch-Bauer I*; figs. 31, 52), and created enthroned Virgins (*Fritza Riedler*; fig. 55).

The reality did in fact resemble this. In his studio he had models available who were prepared to masturbate in front of him (fig. 71) and to pose in lesbian or heterosexual love scenes (figs. 69, 73, 74). The tradition that he was financially generous to these models only partly explains their total dependence on him. They were available to him not only to be sketched, but also "for relaxation." Mizzi Zimmermann and Maria Ucicka are prominent examples. The ladies of Viennese society were both a challenge to him and objects of fear. We know of one successful and one failed attempt he made to possess such a woman. How many other attempts he made, and how often he was successful, can only be guessed.

Between the extremes of the young society hostess and the "poor girl," the *femme fatale* and the object of desire, he also seemed to aspire to the type of woman who was capable of taking her life into her own hands, of remaining independent and belonging neither to one class nor the other: Emilie. He traveled with her to their summer resort every year, and worked together with her. She did not become – apart from the few portraits he made – the object of his art, but remained autonomous. He neither immortalized her, as he did Adele Bloch-Bauer, nor did he have her at his free disposal, as he did Mizzi Zimmermann and numerous other models. He took Emilie seriously, as is shown not only by the postcards, but also by the numerous photos in which they appear together. It is not surprising, therefore, that when he had his stroke he sent for her – not as the woman to "attend his death," but as the woman who, even if only in part, had shared his life.

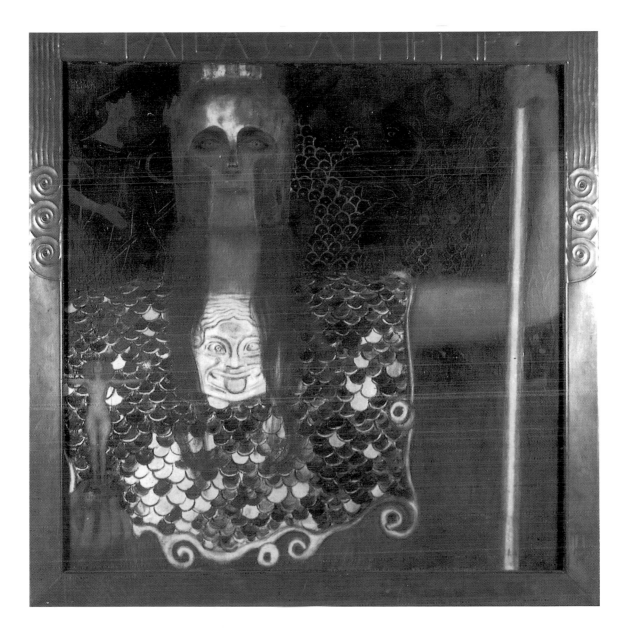

68 *Pallas Athene*, 1898

69   *Recumbent Lovers*, 1902

70   *Danaë*, ca. 1907 - 08

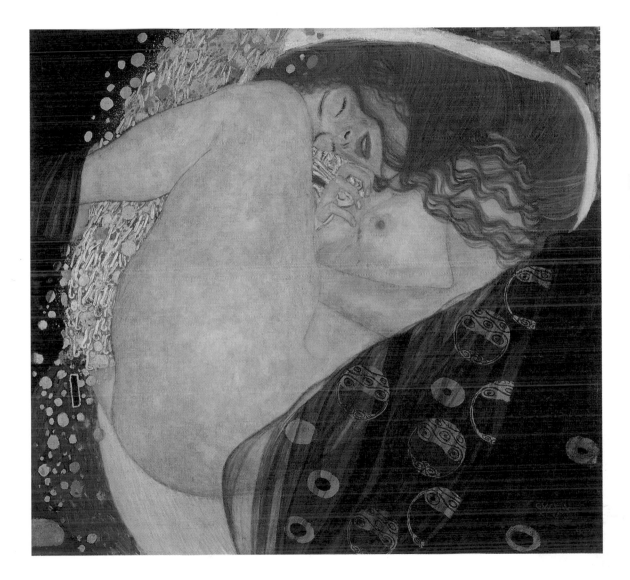

71   *Recumbent Semi-Nude, 1904*

72   *Woman Sitting with Her Legs Apart, 1916-17*

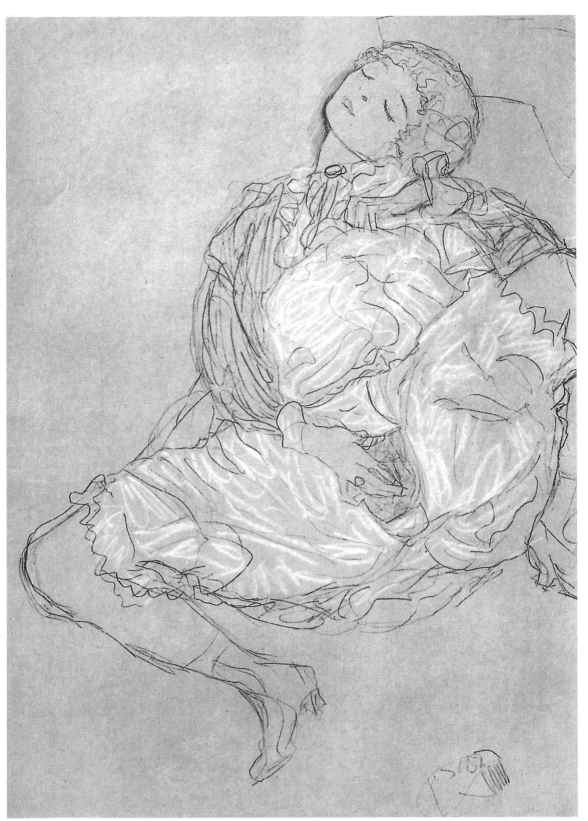

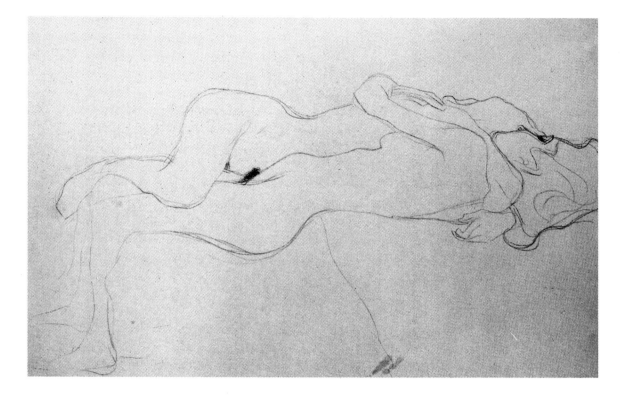

73   *Recumbent Girlfriends Embracing,* 1905-06

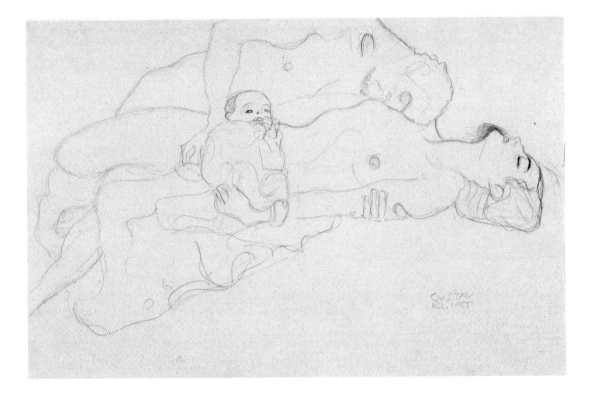

74   *Recumbent Lovers with Child*, 1908-09

# Biographical Notes

*Gustav Klimt · Emilie Flöge*

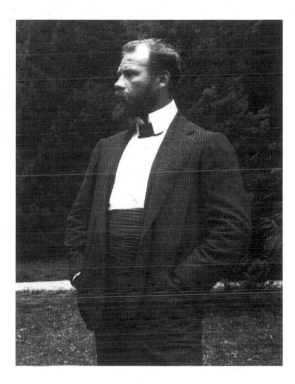

*Gustav Klimt, ca. 1903*

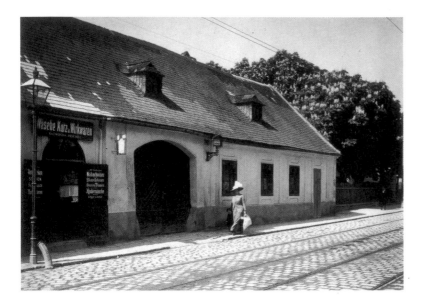

Linzerstr. 247, the house
in Vienna's xɪvth District
where Klimt was born

*Italicized* passages indicate biographical
information on Emilie Flöge.

1862

Born 14 July in what was then the Vienna suburb of
Baumgarten (today the xɪvth District). His father,
Ernst Klimt, (1834-1892), a gold engraver, was from
Bohemia. His mother Anna, née Finster (1836-1915),
was Viennese. The couple are to have seven children,
with Gustav their eldest son.

1867

The Klimt family moves to Vienna. Gustav starts
school in the following year. He attends *Bürgerschule*,
providing basic primary and secondary education,
for eight years. The Klimts live in impoverished
circumstances, and the economic crisis of 1873 puts
the family in financial difficulties.

1874

*Emilie Flöge is born on 30 August. She is the fourth and last
child of the meerschaum pipe manufacturer Hermann Flöge
(1837-1897) and his wife Barbara, née Stagl (1870-1927).*

1876

With his outstanding school graduation certificate,
Klimt applies to the newly founded Arts and Crafts
School (*Kunstgewerbeschule*) of the Austrian Museum
of Art and Industry (today the Austrian Museum of
Applied Arts). Together with his fellow student
Franz Matsch (1861-1942) and his brother Ernst
(1864-1892), he moves after a two-year preparatory
class to the College of Painting to study with Profes-
sors Ferdinand Laufberger (1829-1881) and Victor
Julius Berger (1850-1902).

1879

Ferdinand Laufberger gives the Klimt brothers and
Franz Matsch a share of his commissioned work.
They carry out *sgraffiti* work for him in the court-
yards of the Museum of Art History. In addition,
they take part in preparations for the procession
celebrating the silver wedding of the Emperor and
Empress, directed by Hans Makart (1840-1884).

## 1880
First commission from the theater architects Fellner and Helmer: ceiling paintings in the assembly rooms of the health spa at Karlsbad.

## 1881
Even while they are still students, the Klimt brothers and Franz Matsch hire and share a studio together. Their "artists' company." receives its first commission, the preparation of designs for the portfolio publication *Allegorien und Embleme* (*Allegories and Emblems*), edited by Martin Gerlach in 1882-84 and 1895-1900. They work on the portfolio continuously during the following years. In addition, they are commissioned by Fellner and Helmer to carry out several contracts for theater decoration (ceiling paintings, curtains, etc.). Their claim that none of the three developed a distinct individual style is justified: it is impossible to assign unsigned works to any one of them with certainty.

Members of the Vienna School of Arts and Crafts: Ernst and Gustav Klimt are sitting in the front row next to Professor Ferdinand Laufberger

## 1883
End of their studies. The *Künstlercompagnie* (Company of Artists) moves into its own studio in Sandwirtgasse 8, in the VIth District. Their guarantee to work in the Historicist style, not to allow stylistic differences, and to take over one another's work should one of them be unable to complete it attracts more and more significant commissions. By this time the Klimt brothers have been supporting their family financially for some considerable time.

## 1885
After the death of the prince of Viennese artists, Hans Makart, the *Künstlercompagnie* executes his sketches for the ceiling painting in the Hermesvilla in the suburb of Lainz.

## 1886
The Klimt brothers and Franz Matsch receive their first significant commission, to produce the ceiling and lunette paintings for the staircases of Vienna's new Burgtheater.

## 1888
Paintings for the Burgtheater are completed. The *Künstlercompagnie* receives the Golden Service Medal of the Supreme Imperial House. Franz Matsch and Gustav Klimt paint two views of the interior of the old Burgtheater from different perspectives, Klimt showing the auditorium as seen from the stage.

Gustav Klimt (center) next to Hermann August Flöge, Ernst Klimt's father-in-law (left)

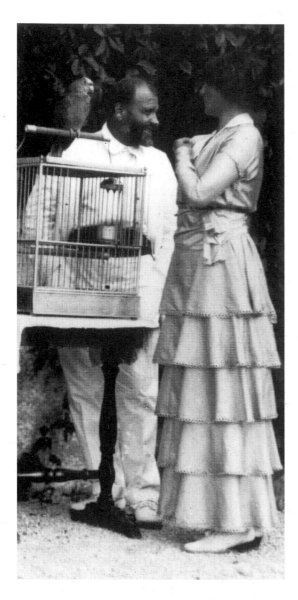

Gustav Klimt and Emilie Flöge at Lake Atter

Gustav Klimt receives the Imperial Prize with a grant of 400 guilders for his painting, the *Auditorium of the Old Burgtheater, Vienna*. He uses the money to finance his first journeys to Munich and Venice. The *Künstlercompagnie* then starts work on the 40 spandrel and intercolumnar paintings in the staircase of Vienna's Museum of Art History. In the depiction of "Antiquity," Klimt's painting *The Girl of Tanagra*, the first signs of a stylistic change in his work can be seen. The figure is shifted to the left, away from the center of the picture, and has the air more of a contemporary figure than of one from ancient history.

1891

After completing the paintings for the Museum of Art History, the Klimt brothers and Franz Matsch join the *Künstlerhausgenossenschaft*, the Vienna artists' association. They have now taken their place among the famous painters of Vienna's Ringstrasse.

*Helene (1871 - 1936), Emilie's sister, marries Ernst Klimt, Gustav's younger brother. Gustav paints his first portrait of Emilie.*

1892

The *Künstlercompagnie* moves into a new studio in Josefstädterstrasse. The building, with an overgrown garden, continues to be Klimt's studio until 1914.

*Birth of Helene's daughter, also called Helene. On 9 December Ernst Klimt dies, and Gustav becomes his niece's guardian.*

1894

Gustav Klimt and Franz Matsch receive a commission to prepare sketches for the painting of the Great Hall of Vienna University. Gustav Klimt's stylistic development results in the gradual dissolution of the *Künstlercompagnie*.

*Klimt completes his brother Ernst's easel painting* The Clown on the Improvised Stage at Rothenburg. *He gives one of the central figures in the painting Emilie's face. A study for the painting shows her in the same costume.*

## 1895

Klimt works on the designs for a new series of *Allegories and Emblems*. In his painting of *Love*, his move toward symbolism becomes clear.

*Pauline (1866-1917), the oldest of the Flöge sisters, opens an educational establishment to train dressmakers, in which Helene and Emilie probably also work.*

## 1896

Although their work is no longer stylistically unified, Klimt and Matsch are commissioned to produce paintings for the University faculties. Klimt is to do *Medicine, Philosophy,* and *Jurisprudence,* and Franz Matsch the remainder.

## 1897

Along with twenty other artists, Klimt resigns from the *Künstlerhausgenossenschaft,* and the Vienna Secession is founded, with Klimt as its first President.

*The first postcard from Klimt to Emilie Flöge that has survived is dated 14 April.*

## 1898

First exhibition by the Vienna Secession, including works not only by the members but also by renowned European artists such as Böcklin, Crane, Klinger, Liebermann, Rodin, Segantini, Stuck, and Thoma. Klimt designs the exhibition poster, showing Theseus fighting the Minotaur under the protection of Pallas Athene. The censors ban the naked figure of Theseus, and Klimt is obliged to conceal Theseus's genitals by means of vegetation. Klimt presents his sketches for Vienna University's Great Hall paintings, and is met with sharp criticism, with specific conditions being imposed for their execution. He produces his first landscape paintings at St. Agatha on Hallstätter Lake (apart from two recently discovered landscapes of 1881, published in the Zurich exhibition catalog of 1992, pp. 52-53).

*Emilie's summer holiday together with Klimt at St. Agatha on Hallstätter Lake.*

## 1899

Completion of the interior decoration of the Music Room in the Dumba Villa on Vienna's Ringstrasse, for which Klimt also produced the painting *Schubert at the Piano.*

*By this time the Flöge sisters are living with their mother at Mariahilfer Strasse 13. They win a competition to produce cambric dresses for a cookery exhibition. (The exact date on which they received the commission is not known.)*

## 1900

At the Seventh Secessionist exhibition, Klimt presents his not quite completed *Philosophy.* The painting creates a furore. Eighty-seven professors sign a petition requesting that it should not be installed in the University's Great Hall. At the World Exhibition in Paris, by contrast, Klimt is awarded the Gold Medal for the painting.

*Emilie and Klimt's first holiday together at Lake Atter. Part of the holidays are always to be spent in the villa of the Paulick family at Seewalchen, to whom the Flöges are related.*

Gustav Klimt, 1908

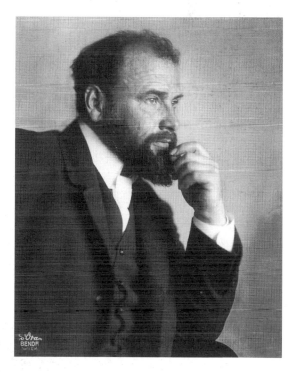

Gustav Klimt in the garden of his studio at Josefstädterstrasse, ca. 1910

1901

At the Tenth Secessionist Exhibition, Klimt presents his *Medicine*, which causes renewed protests, principally because of its nude depiction of a pregnant woman. A proposal by the Vienna Academy of Fine Arts that Klimt should be appointed professor is rejected.

1902

The Secession honors the sculpture *Beethoven*, by Max Klinger, with a large exhibition, for which Klimt provides his *Beethoven Frieze*, which meets with enthusiasm and protests in more or less equal proportions.

*Klimt paints his last portrait of Emilie.*

1903

Klimt travels to Ravenna. The early Christian mosaics there make a lasting impression on him, and are to be reflected in his "Golden Style." In May, the artists Josef Hoffmann (1870-1956) and Koloman Moser (1868-1918) found the Wiener Werkstätten (Vienna Workshops). In the fall, the Secession shows the largest Klimt exhibition yet, with 80 paintings. The *Beethoven Frieze* is left in place especially for the exhibition, and is then purchased for a private collection. (It is today once again installed in the Secession building.) The three "faculty paintings" for the University's Great Hall are shown together for the first time at the exhibition. It is debated whether they should be displayed in the Moderne Galerie.

**1903**

*The Flöge sisters move to the Casa Piccola building at some date between 6 June and 28 November, where they open their fashion-house on 1 July of the following year. The furnishing and decoration are carried out by the Wiener Werkstätten.*

**1904**

Josef Hoffmann and the Wiener Werkstätten are commissioned to build and furnish a villa in Brussels for the industrialist Adolphe Stoclet. Klimt is to produce a design for the *Marble Frieze* in the dining room.

**1905**

Klimt withdraws the finished "faculty paintings" and repays the entire fee, with the assistance of his patron, August Lederer. After prolonged differences of opinion among the members of the Secession, who have split into two stylistic groupings (Impressionism and Art Nouveau), the Art Nouveau artists leave the association.

**1906**

Travels to Brussels to see Stoclet, and to London. The first square portrait is produced. Klimt becomes the President of the newly founded *Künstlerbund* (League of Artists).

**1907**

Completion of the "faculty paintings," which are exhibited in Berlin. Meets Egon Schiele.

**1908**

The "Klimt Group" organizes the *Kunstschau* (Art Show), in which the various types of Art Nouveau are exhibited in 54 rooms. The center of the exhibition is the Klimt Room, with 16 paintings, including *The Kiss*, which is purchased by the Moderne Galerie. Thanks to Klimt's interventions, the young Oskar Kokoschka is allowed to show his work.

**1909**

At the second *Kunstschau*, a survey of contemporary European painting is shown. As well as paintings by

Gustav Klimt, Emilie Flöge, and her mother at Lake Atter, 1912

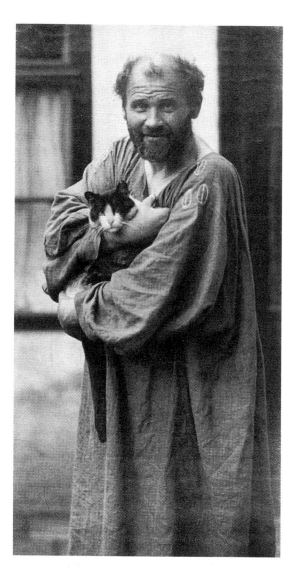

Gustav Klimt in front of his studio, ca. 1912

Kokoschka, the work of Egon Schiele is included. It is the last time that Klimt is to work as an exhibition organizer. In the fall, he travels to Paris, going on to Spain with Carl Moll. End of Klimt's "Golden Style" phase.

*Emilie and her sister Helene travel for the first time to the great fashion shows in Paris and London.*

1910

Klimt shows his work at the 9th Biennale in Venice, and in Prague together with the German *Künstlerbund*. Completes the designs for the *Stoclet Frieze*, which are then executed by the Wiener Werkstätten.

1911

Participates in the International Art Exhibition in Rome, receiving the first prize for his painting *Death and Life*. As his studio is to be demolished, he moves to another in Feldmühlgasse in Vienna's XIII District.

1912

Participates in the *Grosse Kunstausstellung* (Great Art Exhibition) in Dresden. Egon Schiele depicts himself and Klimt in his painting *The Hermits*. Arpad Weixlgärtner writes a long article on Klimt that is published in the journal *Die graphische Kunst*, no 35.

1913

Takes part in exhibitions in Budapest, Munich, and Mannheim.

*Second journey of Emilie and Helene to London and Paris.*

1914

Klimt travels to Brussels to see the completed *Stoclet Frieze* in place. Visits the Musée du Congo there, and is impressed principally by primitive sculptures.

1915

*Klimt paints a portrait of Barbara Flöge.*

1916

Klimt takes part in the exhibition of the *Bund Österreichischer Künstler* (League of Austrian Artists) at the Berlin Secession, together with Schiele, Kokoschka, and Faistauer.

1917

Klimt is elected an honorary member of the Academies of Fine Art in Munich and Vienna.

*Pauline Flöge dies. Helene Donner, née Klimt (1892 - 1980), takes her aunt's place in the fashion house.*

1918

On 11 January Klimt suffers a stroke from which he is never to recover. Dies on 6 February, and is buried at the cemetery in Hietzing. The family declines the offer of a place of honor for him at the cemetery. Numerous paintings lie unfinished in his studio.

*On Klimt's death, his belongings are divided between the Klimt sisters and Emilie Flöge. It is claimed that Emilie burnt many of the letter to him.*

Egon Schiele, *The Deceased Gustav Klimt*, 1918

Death-mask of Gustav Klimt

1938

*Emilie Flöge and Helene Donner are forced to close their fashion-house following the German invasion of Austria and subsequent expropriation or emigration of most of their customers. They move to an apartment at Ungargasse 39.*

1945

*During a fire at the Flöge apartment, 50 of Klimt's sketchbooks are destroyed.*

1952

*Emilie Flöge dies, and is interred in the Flöge family grave.*

# Notes

1 Undated typewritten sheet, University of Vienna Library, inv. no. 152980, cited in Christian M. Nebehay, *Gustav Klimt. Dokumentation* (Vienna, 1969), p. 32.

2 Hans Tietze, "Gustav Klimts Persönlichkeit: Nach Mitteilung seiner Freunde," in *Die Bildenden Künste* (Vienna, 1919), p. 1 ff., cited in Nebehay, p. 267.

3 Nebehay (1969).

4 Tietze (1919), p. 268.

5 Ibid., p. 274.

6 Anton Faistauer, *Neue Malerei in Österreich: Betrachtungen eines Malers* (Zurich, 1923), p. 13.

7 Cited in Nebehay (1969), p. 26; cited most recently by Christian Brandstätter, *Gustav Klimt und die Frauen* (Vienna, 1994), p. 10 ff.

8 Brandstätter (1994), pp. 10-16, applied Freud's *Beiträge zur Psychologie des Liebeslebens* directly to Klimt; Carl E. Schorske, "Gustav Klimt: Painting and the Crisis of the Liberal Ego," in *Fin-de-Siècle Vienna: Politics and Culture* (New York, 1980), pp. 208-78. Schorske provides an excellent analysis of Klimt's paintings for Vienna University's Great Hall, partly with the help of Freudian psychoanalytical theory.

9 Wolfgang Georg Fischer, *Gustav Klimt und Emilie Flöge: Genie und Talent, Freundschaft und Besessenheit* (Vienna, 1987), p. 128.

10 Ibid., p. 23.

11 Brandstätter (1994), pp. 36, 50, 54.

12 The correspondence is arranged chronologically and appears in number order in Fischer (1987), pp. 169-89.

13 According to Nebehay (1969), p. 274, who cites information provided personally by Helene Donner.

14 Martin Green, *The von Richtofen Sisters: The Triumphant and the Tragic Modes of Love* (New York, 1974), p. 257.

15 This is the view taken by Renate Vergeiner and Alfred Weidinger in the catalog *Inselräume – Teschner, Klimt und Flöge am Attersee*, published by the Secession, 88 (1988), p. 32 (Seewalchen am Attersee), by Laura Arici in the catalog *Gustav Klimt* (Zurich, 1992), p. 50, n. 25, and by Wieland Schmied in *Art* (1992), issue 11, p. 30.

16 Christian M. Nebehay, *Gustav Klimt: Von der Zeichnung zum Bild* (Vienna, 1992), p. 240 ff.

17 Thomas Zaunschirm, *Gustav Klimt, Margarethe Stonborough-Wittgenstein* (Frankfurt am Main, 1987), p. 17.

18 In the *rororo Filmlexikon*, vol. 5, p. 1422, the date of birth is given as 1898, but in the literature on Klimt it varies between 1894 and 1899. The entry in the *Filmlexikon* reads, "German director of Austrian origin, née Gustav Klimt. Son of the painter Gustav Klimt...."

19 Reproduced in Alice Strobl, *Gustav Klimt: Die Zeichnungen 1878-1918*, 4 vols (Salzburg, 1982-89), IV, p. 68, no. 3115.

20 Ibid., I, p. 284, gives the dates 22 June 1902-11 September 1902, which cannot be correct.

21 Nebehay (1992), pp. 264-71, where the letters and postcards are published.

22 Christian M. Nebehay, "Gustav Klimt schreibt an eine Liebe," *Mitteilungen der Österreichischen Galerie*, 22/23 (1978/79), no. 66/67, p. 117.

23 Cited after Nebehay (1992), p. 268.

24 Zaunschirm (1987), pp. 27-35, and Alfred Weidinger in the 1992 Zurich exhibition catalog (see note 15), pp. 53-71.

25 Cited in Nebehay (1992), p. 269.

26 On the University paintings see Alice Strobl, "Zu den Fakultätsbildern von Gustav Klimt," in *Albertina Studien*, 4 (1964), pp. 138-69; Peter Vergo, "Gustav Klimts Philosophie und das Programm der Universitätsgemälde," in *Klimt Studien: Mitteilungen der Österreichischen Galerie*, 22/23 (1978/79), no. 66/67, pp. 69-100; Carl E. Schorske, *Fin-de-Siècle Vienna: Politics and Culture* (New York, 1980).

27 Strobl (1982-89), I, p. 274, cites an interview of 1903 as evidence.

28 Cited after Nebehay (1992), p. 269.

29 1992 Zurich exhibition catalog, p. 166.

30 Adele Salomon Grimberg, "Private Love and Public Betrayal," in *Art and Antiques* (Summer 1986), p. 70 ff.

31 This discrepancy was not even noticed by Nebehay (1992), pp. 249-55, who places extracts from Mahler-Werfel's biography alongside the letter from Carl Moll.

32 Ibid., p. 252 ff.

33 Alma Mahler-Werfel, *Mein Leben* (Frankfurt am Main, 1963), p. 26 ff.

34 Gottfried Fliedl, "Das Weib macht keine Kunst, aber den Künstler. Zur Klimt-Rezeption," in Renate Berger and Daniela Hammer-Tugendhat, eds., *Der Garten der Lüste* (Cologne, 1985), pp. 89-149; see especially p. 96.

35 Felix Salten, *Gustav Klimt: Gelegentliche Anmerkungen* (Vienna, 1903), cited after Otto Breicha, ed., *Gustav Klimt: Die Goldene Pforte* (Salzburg, 1978), p. 31.

36 Fliedl (1985), p. 139, n. 26.

37 Arthur Schnitzler, *Komödie der Verführung* (Berlin, 1924), pp. 103, 215, 119, 18.

38 Strobl (1982-89), II, p. 161; III, p. 241; the argument in Grimberg (1986), that the index finger of Adele Bloch-Bauer's right hand was crippled, and that she constantly sought to conceal it, as portrayed by Klimt in all his paintings of her, i.e. the portraits, the depictions of Judith, and *The Kiss*, seems unconvincing.

39 Franz Servaes, in *Der Merker* [Vienna], 3 (1912), issue 3, cited after E. Pirchan in Breicha (1978), p. 36.

40 Arthur Schnitzler, *Komödie der Verführung* (Berlin 1924), p. 102.

41 Bertha Zuckerkandl, 6 February 1936, cited after Christian M. Nebehay, *Gustav Klimt: Sein Leben nach zeitgenössischen Berichten und Quellen* (Munich, 1984), p. 262.

42 See Nebehay (1992), p. 263.

# Works Cited

All quoted material in this publication has been taken from the following sources:

Christian Brandstätter, *Gustav Klimt und die Frauen* (Vienna, 1994).

Wolfgang Georg Fischer, *Gustav Klimt und Emilie Flöge: Genie und Talent, Freundschaft und Besessenheit* (Vienna, 1987).

Gottfried Fliedl, "'Das Weib macht keine Kunst, aber der Künstler' zur Klimt-Rezeption" in Renate Berger and Daniela Hammer-Tugendhat, eds., *Der Garten der Lüste* (Cologne, 1985), pp. 89-149.

—, *Gustav Klimt: Die Welt in weiblicher Gestalt* (Cologne, 1989).

Gerbert Frodl, *Klimt* (Cologne, 1992).

Christian M. Nebehay, *Gustav Klimt: Dokumentation* (Vienna, 1969).

—, *Gustav Klimt: Von der Zeichnung zum Bild* (Vienna, 1992).

Susanna Partsch, *Gustav Klimt* (Munich, 1990).

Alice Strobl, *Gustav Klimt: Die Zeichnungen 18/8-1903* (Salzburg, 1980).

*Gustav Klimt*, exh. cat. (Zurich, 1992).

*Self-Caricature*, ca. 1900

# List of Figures

29 Water Snakes II 1904-07
*Wasserschlangen* II
Oil on canvas
31 1/2 x 57 in. (80 x 145 cm)
Private collection

30 Portrait of
Serena Lederer 1899
*Bildnis Serena Lederer*
Oil on canvas
74 x 32 5/8 in. (188 x 83 cm)
The Metropolitan Museum
of Art, New York

31 Portrait of Margarete
Stonborough-Wittgen-
stein 1905
*Bildnis Margarete Stonborough-
Wittgenstein*
Oil on canvas
70 7/8 x 35 3/8 in. (180 x 90 cm)
Neue Pinakothek, Munich

32 Emilie Flöge in a summer
dress 1907
Photo: Gustav Klimt

33 Emilie Flöge in a concert
dress 1907
Photo: Gustav Klimt

34 Emilie Flöge in a summer
dress 1907
Photo: Gustav Klimt

35 The Virgin 1913
*Die Jungfrau*
Oil on canvas
74 3/4 x 78 3/4 in. (190 x 200 cm)
Národní Galeri, Prague

36 Hermann Bahr 1909
Photo: Dora Kallmus

37 Stoclet Frieze 1905-11
*Stoclet-Fries*
Palais Stoclet, Brussels

38 Emilie Flöge in a "Reform
Movement dress" 1905-06

39 Postcard to Emilie Flöge
July 6, 1908

40 Postcard to Emilie Flöge
July 6, 1908

41 Koloman Moser, silver neck-
lace with rhomboid decora-
tions and semi-precious jewels
Private collection

42 Josef Hoffmann, silver chain
with heart-shaped pendant
Private collection

43 Sketch of the Deceased
Otto Zimmermann 1903
*Der tote Otto Zimmermann*
pencil

44 Schubert at the Piano 1899
*Schubert am Klavier*
Oil on canvas
59 x 78 3/4 in. (150 x 200 cm)
Destroyed by fire at Schloss
Immendorf in 1945

45 The Sunflower 1907 (detail)
*Die Sonnenblume*
Oil on canvas
43 1/4 x 43 1/4 in. (110 x 110 cm)
Private collection

46 Beech in a Forest ca. 1903
*Buche im Wald*
Private collection

47 The Big Poplar II 1902-03
*Die grosse Pappel* II
Oil on canvas
39 3/8 x 39 3/8 in. (100 x 100 cm)
Collection of Dr. Rudolf
Leopold, Vienna

48 Medicine 1900-07
*Die Medizin*
Oil on canvas
14 ft. 2 in x 9 ft. 10 in.
(430 x 300 cm)
Destroyed by fire at Schloss
Immendorf in 1945

49 Hope I 1903
*Die Hoffnung* I
Oil on canvas
71 1/4 x 26 3/8 in. (181 x 67 cm)
National Gallery of Canada,
Ottawa

50 "The Malevolent Powers,"
detail of the *Beethoven Frieze*
1902
*"Die feindlichen Gewalten"*
Frieze: 7 ft. 3 in. x 78 ft. 9 in.
(220 x 2400 cm)
Secession, Vienna

51 Hope II 1907-08
*Die Hoffnung* II
Oil on canvas
43 1/4 x 43 1/4 in. (110 x 110 cm)
The Museum of Modern Art,
New York

52 Portrait of
Adele Bloch-Bauer I 1907
*Bildnis Adele Bloch-Bauer* I
Oil on canvas
54 3/8 x 54 3/8 in. (138 x 138 cm)
Österreichische Galerie, Vienna

53 Study for *Judith I* ca. 1899
Pencil
5 3/8 x 3 1/4 in. (13.8 x 8.4 cm)
Sonja Knips's sketch book

54 *Judith I* 1901
Oil on canvas
60 1/4 x 52 3/8 in. (153 x 133 cm)
Österreichische Galerie, Vienna

55 Portrait of
Fritza Riedler 1906
*Bildnis Fritza Riedler*
Oil on canvas
60 1/4 x 52 3/8 in. (153 x 133 cm)
Österreichische Galerie, Vienna

56 *Judith II* 1909
Oil on canvas
70 x 18 in. (178 x 46 cm)
Galleria Internazionale d'Arte
Moderna di Ca'Pesaro, Venice

57 Portrait of
Adele Bloch-Bauer II 1912
*Bildnis Adele Bloch-Bauer* II
Oil on canvas
74 3/4 x 47 1/4 in. (190 x 120 cm)
Österreichische Galerie, Vienna

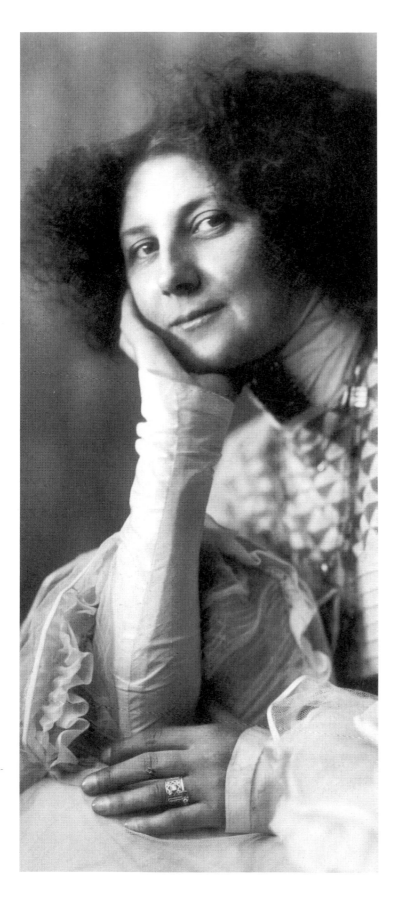

1  Emilie Flöge, 1909